DIALECTS

FOR THE STAGE

DIALECTS

FOR THE STAGE

EVANGELINE MACHLIN

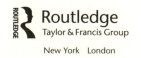

Routledge
Taylor & Francis Group

New York London

Published in 2006 by
Routledge
Taylor & Francis Group
270 Madison Avenue
New York, NY 10016

Published in Great Britain by
Routledge
Taylor & Francis Group
2 Park Square
Milton Park, Abingdon
Oxon OX14 4RN

© 2006 by Taylor & Francis Group, LLC
Routledge is an imprint of Taylor & Francis Group

Printed in the United States of America on acid-free paper
10 9 8 7 6 5 4 3 2 1

International Standard Book Number-10: 0-87830-200-X (Softcover)
International Standard Book Number-13: 978-0-87830-200-0 (Softcover)

Library of Congress Cataloging-in-Publication Data

Catalog record is available from the Library of Congress

Taylor & Francis Group
is the Academic Division of Informa plc.

Visit the Taylor & Francis Web site at
http://www.taylorandfrancis.com

and the Routledge Web site at
http://www.routledge-ny.com

PUBLISHER'S NOTE

Publisher's note: The text of *Dialects for the Stage* has been modified from the original edition to correspond to CD format.

DEDICATION

Dedicated to Robert M. MacGregor,
late director of Theatre Arts Books,
my publisher and good friend,
without whose faith, hope and charity, this
work would never have been completed.

E.M.

CONTENTS

1
THE ACTOR, THE CDS
AND THE MANUAL

Any actor who can sing a tune can learn to speak a dialect. Each dialect is like a song with words and music, the words having their own special pronunciations, the inflections having their own special tune. The CDs give you the music and the words as spoken. The manual gives you the words written out. CDs and manual together enable you to learn any of the twenty dialects presented or either of the two standard speech forms of English that are included. Thus, you will see a dialect in print while you hear it in recorded sound. Following and learning with both ear and eye, you will begin to speak the dialect well in a surprisingly short time.

The CDs and the manual are arranged for the play-it-and-say-it method of dialect acquisition. This method was developed by me working with students of Boston University's Division of Theatre over several years. A special method of spacing the first dialect selection in each group on the CD permits you to reproduce it readily in short units. After this you proceed to longer ones, following a sequence explained in Part Three. Playing and saying the examples systematically and repeatedly, you soon become competent in reproducing them exactly, with their sound changes and inflections. Later you transfer these to other material in the dialect, then to improvised material, and so to the lines of a dialect role.

Dialect roles in plays are quite common. Entire plays in dialect are not rare. As an actor, the learning of accents and dialects is a challenge that you must meet to improve your chances of being cast in a

1

variety of roles. The first break into the professional theatre may be the hardest to get. An actor needs every possible asset, and skill with dialects can be an important one.

The term "dialect" in this manual refers to variant speech forms of English used by native speakers of English. The term "accent" is used for variant forms used by those whose native tongue is not English. However, one born in the American South, perhaps, or in the Lowlands of Scotland, who has spoken the speech of his region from childhood on, will be unlikely to call his own speech a dialect. He is more likely to describe it as "my Southern accent" or "my Scottish burr," perhaps because the word "dialect" seems to suggest uncultivated speech.

The CDs present three broad groups of examples: a North American dialect group, a British dialect group and a group of European accents. Two black African examples are presented in conjunction with black American. An accent that I have called "General European," which is cosmopolitan in nature, follows the last of the European accents. The CDs also present two types of standard English—a selection of speakers of standard North American, including one Canadian, and a variety of speakers of standard British, several of whom use "received English," as it used to be called.

None of the dialect groups presented is in any way exhaustive. Those included have been selected to serve the actor's purpose, not the linguist's. Some that may have a limited use have been omitted for lack of space. In the North American group, Pennsylvania Dutch, Cajun, Newfoundland and North American Indian dialects are not represented. Nor are many subdialects of the West and South. The Midwestern group on CD One represents only the dialect speech of the extreme southern boundaries of the Midwest, which is a vast region, geographically stretching east from the Rockies to the Alleghenies and north from the Ohio River and from the states of Missouri and Kansas into the Canadian prairie provinces. Its many near-dialects flow and merge into one another, but are most sharply defined in the border examples given.

All dialects at the present time are suffering from erosion, due to the ubiquitous influence of radio and television, and the increasing importance of speech education departments in universities. Dialect traces persist in some areas, especially among the older generation, but are fading from the speech habits of many of the younger generation. A great richness and diversity is thus beginning to pass from common speech. Dialect usage remains, however, as an element in many important plays, and this manual and the CDs aim at preserving source material from living dialects for the actor's use.

Three or more examples of each dialect or accent are presented on the CDs. These differ more or less from one another, according to the speaker's background or locality. They have been chosen to give the actor a rich source to choose from and the variety that may be necessary for different types of authentic characters. They are in no sense complete linguistic offerings. The standard speech examples, North American and British, are included for two reasons. First, a Canadian or an American actor often needs to use "cultivated" British speech, while British actors frequently need to appear in American or Canadian plays, where standard North American is appropriate. Second, an actor, like any professional person, may wish to standardize his own speech, if it has traces of regionalism. "My dreadful Noo Joisey speech!" cries a student actor in an eastern college. "Ah mun be rid of it, tha knowest!" exclaims the Yorkshire lad in a British drama school. Both need to realize that standard English speech may be learned as one learns a dialect. Not for nothing did the Hungarian professor, hearing Eliza Doolittle's faultless English at the ball in *My Fair Lady*, declare, "She speaks English as those who have been taught!"

What a character is saying in dialect on the stage must be comprehended by the audience. If the dialect is too heavy, the audience will miss some of the lines and much of the pleasure they expected, eventually becoming bored and restless. By contrast, the speakers on the CDs may all, with one or two exceptions, be readily understood by either a British or an American ear. When you begin to learn any dialect, bear this in mind: Keep your sound changes few, but consistent. An audience subconsciously recognizes consistency in a speaker's style and accepts his dialect as genuine.

Merely making the selected sound changes of a dialect is not enough. There is also the lilt to learn. This lilt or speech melody is an essential part of each dialect. Irish particularly has its musical rise and fall:

 DAR-
He's a lin' man, a DAR-
 lin' man."

"A HAND- NO-
 some young fellow, with a ble brow."

New England Yankee speech has a falling inflection between syllables or even within one:

```
                                              AY-
   "I'll just set here on the po-     for a mite of
                          erch                    uh."
```

The pitch and rhythm changes of a dialect make a kind of tune, often with a recurring phrase like a theme in music. It is this element which makes an acquired dialect truly authentic. Be sure to recognize it and learn it. Foreign accents possess lilts too. They are usually the typical inflections of the language, carried over persistently to the English syllables. It happens in French-accented English. "There is a rhythm, a rhythm that one falls into naturally," says the fourth speaker of that accent (p. 116). In the Italian examples, you will even hear some English words modified to make them fit the native Italian lilt: "The sun-a she's-a just-a coming up-a" (Italian No. 3, p. 120). You should adopt and follow this feature.

Dialect speaking on the stage must be relaxed and natural. Do not let the use of the sound changes and the lilt put a straitjacket on your acting. Rather wear them so often in improvising in the dialect both out loud and in your head that they come to fit comfortably at last over your regular speech, like a well-worn coat. This effort may take one week; it may take six weeks. After a number of play-it-and-say-it practice sessions, launch into the dialect courageously, in season and out. One of my students did this. He worked hard to acquire a Welsh dialect for *The Corn Is Green*, so that by performance time he could use the proper lilt and all to great effect in the play. Later, in a restaurant, student friends asked him to assume it again for fun. Carried away, he let himself go, improvising freely. A waitress, overhearing, came up to them in great excitement. She cried, in her own Welsh accent, "And what part of Wales did YOU come from?"

Because the examples in each dialect differ from each other, you should select as your chief model the one which seems most appropriate for the role you expect to play. How to choose this is discussed further in Part Two. However, always work first with the spaced example, No. 1. It may be the only one you need. Surprisingly, you can become fluent in a dialect working from a single good model if you immerse yourself in it until you have words and tune by heart.

Enjoy these dialects. Learn them for pleasure and for profit. Throw away your inhibitions as you practice. Remember that your own ears will be affronted if not outraged when your own voice speaks in strange accents. Your feedback hearing system will be disturbed at Russian or French-Canadian or Welsh sounds coming out of your mouth, instead of the familiar American, Canadian or British

ones. Ignore this feeling, and push on till the new sounds and inflec-
tions become your own.

At the end of CD Three, there is a special help for dialect learning,
the International Phonetic Alphabet, presented in sound. It is included
for actors who learned it once and have forgotten it through disuse
and for those who will take the trouble to learn it for the sake of
reproducing new pronunciations not met with on the CDs. The IPA, as
it is called, spells by sound elements only. One phonetic symbol stands
for one sound element, or phoneme, and for that one alone. Many
of these symbols are the same as the letters of our regular alphabet.
Others are different but easily learned. On CD Three the sounds for
the symbols are spoken in groups. They are presented in the same order
in Part Eight of this manual. For a fuller treatment of the subject and
a method of learning the IPA easily as you work with your voice, see
my *Speech for the Stage*, Chapters 8 and 11. Once you have learned
the IPA, you can write out the sounds of an unfamiliar dialect with
absolute accuracy. It is what Professor Higgins of *My Fair Lady* and
Pygmalion was doing that rainy night in London when he first heard
Eliza Doolittle's Cockney.

However, since many actors are unfamiliar with the IPA, words
heard on the CDs with dialectal variant sounds are respelled phoneti-
cally in this manual, using the ordinary alphabet, not the IPA alphabet.
The Southern *I*, for instance, is respelled *Ah*. The New York-Brooklynese
"shirt" is heard as *shoit*, and is so respelled. The respelling for each
variant is as phonetic as possible. But you must always remember that
respelling is suggestive rather than exact as to the pronunciation it rep-
resents. It is the best that can be done to show dialectal pronunciations
using the letters of the alphabet. The dialect pronunciations that you
must learn are those HEARD ON THE CDs. There only can you discover
exactly what the respellings are meant to stand for. Guiding yourself
by what you *hear* rather than by what you *see*, you will safeguard
yourself against mistakes in dialect reproduction.

If you are to become an expert in this field you will do well to make
the effort to learn the IPA and to use it, not only with the material in
these examples, but in working with new material or in writing out dia-
lects as you hear them in life. Reading your transcriptions, you will find
you are reproducing exactly what you heard, which is the aim of dialect
learning. The IPA gives a total correspondence between what is written
and what is heard. Thus, even if you hear a dialect speaker when you
have no recording device at hand, you will not lose the opportunity to
record his speech. You can immediately make a perfect record in writing
and add it to your growing store of dialect information.

2
USING THE DIALECT TEXTS
AND THE DIALECT DATA

The complete text of each example in each dialect group is presented in Parts Four, Five, Six and Seven of this manual. The examples are titled and arranged as on the CDs. Additional data are provided with the text as are aids to learning the dialect. For the sake of simplicity, the word "dialect" is used here and throughout the rest of the manual in most cases as a covering term, standing for all the groups, except the two standard forms of English.

The kinds of data presented with the texts of the transcriptions are:

Spacing Data
Pronunciation Data
Inflection Data
Pronunciation Notes
Vowel and Consonant Changes
Colloquialisms and Idioms
Notes for American, Canadian and British Actors
Inflection Notes
Character Notes
Lists of Records and Plays for Study

Spacing Data
The first example of each group is handled differently from the others in the matter of spacing. *It is repeated on the CD in short units, with*

silent spaces between. The other examples are not repeated; they are heard once only.

When you listen to the first example repeated, you hear a short bit, followed by a silence during which you are to say the bit you just heard. As you finish, the next bit on the CD begins; you repeat this during the next silent space. You continue to do this throughout the repetition of the first example, simply listening to a bit (hereafter called a unit), and saying it during the silent space provided.

With the other examples, you will have to stop and start the CD yourself, and then repeat what you just heard. After repeating it, you start the CD again and listen to the next unit. Then you stop the CD again and repeat that unit. You continue in the same way throughout the example.

To show you where to stop for each unit, the text for each example is broken up by *slash* lines, *single* and *double*. The slashes are stopping places that have been worked out for comfortable repeating of a phrase or sentence. At first, stop the CD every time a single or a double slash is reached, and repeat aloud what you heard. As the material gets familiar, go through the example again, stopping only at the double slashes. Now you will be saying a bit two units long. For instance, Midwestern No. 2 begins:

"This li'l NOOSPAPER clipping is ENTAATLED /

" 'Lou Teaches HERRBIE How to Hunt for an Ancient Mule.' " //

On the first few rounds, you stop the CD after "ENTAATLED" and repeat to that point. Then you stop it at "Mule" and repeat only the second unit, "Lou Teaches HERRBIE How to Hunt for an Ancient Mule." You continue so, unit by unit. Later you go through the CD not stopping at "ENTAATLED"/ or at any single slash, but at the double slashes only. With this step, you extend your ability to keep to the dialect.

When a triple slash appears about halfway through one of the longer examples, as in the case of Midwestern No. 2, "he'd take care of the mule,"/// it indicates a special stopping place that divides the example in two. When you know the first half well, start to repeat it from the beginning and do not stop until you reach the triple slash. As soon as possible, say the second half at one go in the same way. Finally, repeat the example from beginning to end without a stop.

In a few cases, only part of the first example is spaced. Midwestern No. 1, the very first item on the CD, is so treated. This is to avoid repetition. In a few other cases, the first example is divided into two parts, spaced separately, as the content suggests.

Pronunciation Data

To call your attention to the sound changes of a dialect, the words in which you hear these changes are respelled in the texts of the transcriptions as phonetically as possible. These respelled words are presented in capital letters in the transcription texts, and in italics in the text that is not from transcriptions. The regular spelling is given in the margin in the few cases where it is necessary for your understanding of the word, as, for example, in Midwestern No. 1: "from here to SAALOAM Springs." *Siloam*

Respellings are consistent. One spelling is always used for the same sound. Long *a*, for example, is always respelled *ay*, sounded as in "day." Nasalized vowels, very important in dialects such as Southwestern, Yankee and Cockney, are shown by doubling them: *caan't* (Midwestern No. 2), *skiin* (skin), *kiitchen* (Southwestern No. 2). The doubling represents both the change in quality and the lengthening that results from nasalization. If the lengthening is a real drawl, this is shown by both doubling and hyphenating the nasalized vowel: *bri-idge, tha-at* (Midwestern No. 3). Since the respelling *aa* usually means the vowel change heard in *Saaloam*, when it is also nasalized, this is shown in a footnote. See p. 23.

Inflection Data

A group of words or sentences in each example is printed in *italics*. This is to alert you to the fact that these are spoken with an inflection and a rhythm especially characteristic of the dialect. It is essential that you use these inflections and rhythms when you speak in the dialect. You must become so familiar with them that you hear them in your head as you hear a tune you know. For this reason, you must gradually learn by heart the examples you are working on, not just the words, but the words with their sound changes and inflections. Play the italicized sentences over and over, concentrating on the leaps and slides in pitch upward or downward from one word to the next. Take your speech through exactly the same leaps and slides, no matter how odd they sound to your ear.

If you have a musical ear, you will quickly learn the dialect's tune and will hear it recurring over and over, both as you listen and as you speak. If you lack this facility, follow the method for learning a lilt suggested in Part Three, Step 12.

Pronunciation Notes

Comments on the pronunciation features of a dialect are given in this manual directly following the texts of the examples themselves. They

explain many things, including why the sound changes may not be consistent in the different examples.

Vowel and Consonant Changes

Vowel and consonant changes are assembled following the pronunciation notes. They are listed in the order of their importance to the dialect, not alphabetically. Sometimes sound changes common to the dialect which do not happen to occur in the examples on the CDs are added for the sake of completeness. Likewise, less common sound changes which do occur in the examples may be omitted because they are unusual and because, as noted in Part One, sound changes in general should be few.

If two speakers in a group pronounce the same dialect word somewhat differently, your attention is directed to the commoner variant of the two. This is the one you should use.

Colloquialisms and Idioms

Colloquialisms are spelled as they sound: takin', lotsa. You should accept and use such colloquialisms as an essential part of the dialect. Expletives that occur in a dialect are spelled as they are pronounced, "Blimey!" (Cockney). Idioms like "Hares vunding" (Welsh No. 2), if obscure, are translated in a footnote. Learn expletives and idioms along with their inflection patterns, and use them freely when improvising in the dialect, as discussed in Part Three, Steps 10 and 11.

Notes for American, Canadian and British Actors

Notes for American and Canadian actors describe in detail the subtle vowel and consonant changes necessary for British speech. Notes for British actors suggests that they adopt, as part of educated American speech, pronunciations like "styoodent", "ciddy", "bahx," which are standard for most North Americans. But see p. 76: an American says "styoodent" and "nooclear" in the same sentence.

Inflection Notes

These are sometimes discussed separately, sometimes under the same heading with pronunciation notes. They draw your attention to special features of a dialect's inflection such as its rhythm, tempo and stress. Rhythm (the flow of a sentence), tempo (the speed of a sentence) and stress (the beat, heavy or light, on a syllable; we call it *beat* rather than *accent* to avoid confusion) are all part of the inflection pattern. Use the inflection notes to guide you in mastering this aspect of the dialect.

Character Notes

These are discussed separately, except in the case of European accents, where they are discussed under one heading with pronunciation and inflection notes, because of the close interrelation between them.

The character notes help you to decide on which of the dialect examples presented you will base your assumption of the dialect. Because many of the speakers are native users of the dialect and because their conversations are unrehearsed, the personalities and temperaments of the speakers come through, evident in both content and in style. The notes point this out and suggest how you may handle these in using the dialect for the role you will play, urban or rural, comic or straight.

Lists of Recordings and Plays for Study

The recordings listed include speakers or singers using the dialect. Procure these recordings and listen to them to widen your knowledge of the dialect as a whole. Try especially to get those recordings from which excerpts have been copied (with permission, of course) and used as examples on the CDs. These are the best recorded examples I know of the dialects presented.

The plays listed for each dialect or accent are suggested as material for practice. Many of them contain one or more characters whose dialogue is respelled in the dialect. The names of these characters are listed beside the title and author of the play. Other plays suggest by their plot or locale the possibility of using dialect speech for one or all of the characters. In Peter Ustinov's *The Love of Four Colonels*, for instance, the characters are American, English, French, Russian and German. The American and the Englishman may each speak his brand of standard English, while the others may use French, Russian and German accents. In other plays or musicals, *Gigi*, for instance, precedent suggests an accent, though the script is not respelled to show it. Maurice Chevalier's urbane French accent in his often-heard "Thank Heaven for Little Girls" almost compels succeeding singing actors to use one too. In plays like the one-act *A Sunny Morning*, by Serafin and Joaquin Alvarez Quintero, that has a park in Madrid for the locale, the characters' names, Doña Laura, Don Gonzalo, Petra and Juanito, and the use of words like *adios, señor, señora* make the dialogue appropriate for application of a Spanish accent, regardless of the ordinary spelling.

Actually, you may be safer working with lines that have not been respelled, if your dialect or accent is among those presented in this manual and on the CDs. The most careful of playwrights devises his

own respelling as best he can. But it is a partial and often an inaccurate guide to pronunciation.

In *Henry V*, Shakespeare suggests the French princess Katharine's accent by "I cannot tell vat is dat," which might stand for either French or German. Shaw struggles to respell Irish with little success. In *John Bull's Other Island*, Tim says, "I'm Irish, sir; a poor ather, but a powerful dhrinker." "Ather," which seems to rhyme with "lather," hardly conveys how an Irishman says "eater." Even O'Casey does little more in the way of respelling than drop the *g* from the present participle: "It's a wild night, God help you, to be out, and the rain fallin'." However, the rhythm of his lines always suggests the needed lilt. With Cockney, many playwrights depend on totally inadequate dropping of the initial *h*. Even Shaw does not respell Snobby Price's line in *Major Barbara*: "Well, I'm a real painter: grainer, finisher," though its sound, as heard on CD Two spoken by a British actor on Caedmon's record *Major Barbara*, is respelled on p. 85 of this book as "well, I'm a real pyntuh. Grynuh. Finishuh!"

Keep in mind, then, that the dialect respellings found in play scripts are usually inaccurate and incomplete, and cannot show the essential lilt. Avoid following them. Rather, work through all the steps in Part Three, and use the method described in Step 12 to apply your dialect to a character's lines. In this way you are free from dependence on what the playwright has written, and if a director wants you to use a dialect for a role where no respelling has been used, you will be able to fulfill his request.

If you are working with a group studying dialects, and have arrived at Step 11 of Part Three (p. 17), one play which offers a real challenge is *The Great White Hope* by Howard Sackler. The long list of dialects and accents called for in this play is given below. It is especially recommended because the dialect respellings are careful and more than usually accurate. This is particularly true in regard to black American dialect, of which there is a great deal in the play. The respellings distinguish between genuine black American and traditional deep South black speech, as in the *Uncle Tom's Cabin* scenes, Act II, Scene 6, and the lines of the Blackface character in Act I, Scene 3. In another instance, the role of the African Negro student requires the actor to superimpose a German accent on black African English. If you have some facility in dialect acquisition, try this. You should acquire the black African dialect first, and then work out the fascinating problem of rendering it with a German accent. Finally, you must hold to it in rehearsal and performance against the speech of the American and German characters in Act II, Scene 5, set in Berlin, in an outdoor café.

Another play needing many dialects is *Riel*, by John Coulter. Set in the Canadian Northwest of the nineteenth century, it requires North American and British dialects, educated and uneducated. Because its theme is based on ethnic and religious conflicts, the use of dialects is essential.

In the list below, as with all plays suggested for dialect study in this manual, only those roles in which the characters may or must speak in dialect are named. The dialect or accent is given first, then the name of the main characters who use it.

The Great White Hope by Howard Sackler

Black American, genuine	Jack, Tick, Clara, others
Black American, traditional	Jack, Tick, Ellie, Blackface (in scenes listed above)
Standard North American	Ellie, Negro doctor, others
New York-Brooklynese	Cap'n Dan, Pop, Fred
Standard British	Sir William Griswold, Mr. Coates, Mr. Treacher
French accent	Promoter
German accent	German officers
Mexican accent	Boy, El Jefe
General European (Hungarian)	Ragosy
Black African spoken with a German accent	African Negro

Riel by John Coulter

Colloquial French Canadian	Riel*, other Métis, Andre, Quebec mob
Educated French Canadian	Cartier, Chapleau, Taché, Dr. Roy
Standard British	Colonel Dennis, Colonel Wolseley
Standard North American	Sir John A. MacDonald, Judge Richardson, Smith, others
Scottish	Rabbie
Irish	O'Donoghue, Ontario Irish (Orangemen), Scott, Ontario mob
Cockney	Sergeant
New York-Brooklynese	Marc

*Riel, educated in Montreal, may use either type of French Canadian.

3

STEPS IN THE PLAY-IT-AND-SAY-IT METHOD OF LEARNING DIALECTS

STEP 1

Listen to all the examples for the dialect group you are working on. Note carefully the sound changes and typical inflections, as indicated by special type faces in the text.

Each example is announced on the CD by its dialect name, number and title: "Midwestern No. 1, *Fishing at Three Fingers Bay, Oklahoma*." The first example, usually all of it, is repeated spaced, for easy play-it-and-say-it practice. The texts are presented in the same order as on the CDs.

STEP 2

Listen to the first example a number of times.

STEP 3

Speak along with the speaker right through the first example. Keep up with him. Don't look at the text at this point.

STEP 4

Play and say the first example as spaced on the CD. Start to say each unit the instant it is finished. Try to say it in the time allowed. If at

15

first you cannot repeat it all, *repeat at least the last bit you catch*. After several such repetitions you will become familiar with the material, and should push yourself to say all the unit in the silent space that follows it. Match the pronunciations and inflections by ear as closely as you can at this stage. *Don't look at the text yet.* Repeat this until you feel you are matching each unit well.

STEP 5

Open this manual at the text of your example. Lay it beside your CD player. Look at the text, and note where the double slashes occur— after each *second* short unit of the transcription. Return the CD to the beginning of the first example. Play and say it, pausing the CD yourself at each double slash in the text. Say the double unit you heard, and then at once start the CD again. Stop it again at the next double slash, and say that double unit. Continue so to the end of the example. Continue this until you can readily duplicate each double unit.

Don't work too long at one time. The effort of concentration is tiring. Better to work for a short time, fifteen minutes or half an hour at one sitting, returning later the same day or the next day. Be sure to work daily, however, not letting days pass without going back to the CD and the playing and saying of the dialect. Follow this rule and you will gain ground quickly. Otherwise, you will lose it just as quickly.

STEP 6

Play and say the first half of the example, stopping the CD at the halfway triple dash, if there is one. Play and say the second half in the same way. Be alert to pronunciation changes and the inflection-rhythm pattern. Say each half by heart as much as possible. Watch the text if you must, but aim at getting it by heart quickly, complete with the exact sounds and inflections you hear.

STEP 7

Play and say the whole example at once. Say as much as you can by heart. Use the text only when you forget the words or the sound changes and inflections. By now you may be hearing these in your head like a tune. This means you have an auditory image in your mind which you can refer to at will. Use your ear to tell you if you are singing the dialect's tune when you speak the passage, as well as using its pronunciations.

STEP 8

Now record yourself. Play successively the original and your recorded reproduction of it. Notice where you failed to reproduce it exactly. Mark these words or sentences in the text, and write out exactly what your errors were, using a notebook you will keep for the purpose. Did you get the drawling inflection of "He's gonna pull you off into the RII-VER"? (Midwestern No. 1.) Did you pronounce properly "TARRS a-screamin'"? (Midwestern No. 2.) If not, go back to Step 4, and practice especially the units in which your mistakes occurred. Then record the whole again on your blank tape, following your first effort. Play both successively, and see how you have improved. Continue this process until you can satisfactorily record the whole.

STEP 9

Work in the same way with one or more of the other examples in the group, using first the one most appropriate for the role you have in mind.

STEP 10

Improvise in the dialect, with a partner or by yourself. Listen to those improvisations on the CDs where the speaker has assumed a dialect not his own and improvised in it. Some of these are Yankee No. 4, Yiddish No. 3, Cockney No. 3, North British No. 4, Irish No. 3 and Italian No. 3. These are all improvisations by actors who acquired the dialect by the play-it-and-say-it method. Do as they did; invent your character and situation and let yourself go in it. Introduce the idioms and expletives of the dialect as often as you can. Don't worry about mistakes and inconsistencies. Do not even record your improvisation attempts until you begin to feel at home in the dialect as you speak it. When finally you record yourself, check carefully to see what your inconsistencies are. Try to correct them by going back to earlier steps, 4, or 5 or 6. Then do a new improvisation, record it and check it as before. You will steadily move toward a confident authenticity.

STEP 11

Improvise a scene in your dialect with several other actors in your group, each doing a different dialect or accent. Invent some appropriate situation, perhaps a passenger check at an airport, or a national or

From Yankee, No. 1

Fred Saw-yer died back in THUHT-TY sev-en. They had to dig 'im

up last YEE-UH, to make way for the State Turn-pike. There's

a LA-AW that says that some mem-ber of the fam-ily's got to

be TRAY-UH when they lift 'im AOWT.

From Cockney, No. 1

Feel bet-ter ART-ER your meal, sir? Eh? NAAOH. Call that a meal? Huh!

Good e-nough for you, PRAPS; but wo' is it to me, an in-tell-i-gent

work-in' man? Work-in' man! WOT are yuh? (He he!) PYN-TUH. YUS, I DES-SYE.

AAOH YUS, you DES-SYE. I know!

international convention on some controversial topic. Let the dialogue or the debate be vigorous and uninhibited, comic too if the mood so strikes you. Keep your own contribution lively, bringing in idioms and expletives freely. Get your ears used to your voice speaking in one dialect against other voices speaking other dialects. When you can hold your own in such a situation, you will recognize the fact by listening to the group improvisation as recorded. If you did well, you can feel assured that you are already competent in the dialect.

STEP 12

You are now ready to apply the dialect to dialogue in a play. Note both the words in which sound changes must occur and sentences which are likely vehicles for the typical inflections. Respell the former and apply the inflection pattern to the latter. If you lose the lilt as you speak, try writing out a pattern of dots on a musical staff for these sentences, placing the dots high, middle or low to show the rise and fall of the speech melody as notes show a tune. Write the words below the staff, each word under its own pitch dot, as shown here. When slides in pitch upward or downward occur, use commas up or down from the pitch dot to show this.

When you have written out in this manner the lines your character speaks in dialect, speak them a few times, following the dots with your eyes and your voice, changing over from your usual inflections to those of the dialect. Record yourself doing this, and compare how you sound with the example on the tape which you chose as your model. Make any needed changes in the transcription; speak the lines as rewritten, and again compare the result with your model. For further details about learning and using pitch transcriptions, see my *Speech for the Stage*, Chapters 9 and 11.

As you rehearse for a performance using a dialect, think a lot about the character you will portray. Let your approach be more psychological than linguistic. Certainly you will use the right sound changes and inflections. But as you get beneath them into the personality they express, they will begin to occur naturally. You will think in the dialect. Suppose you have a Yiddish role to prepare, say that of Solomon in Arthur Miller's *The Price*. You will, of course, base yourself on Yiddish No. 2. As you work, learn not only the pronunciations and inflections, but get to know the history and personal qualities of the speaker of Yiddish No. 2. You can hear and feel them in the tones and cadences, the recollections, questionings and assertions of this speaker. You may wish to create Solomon after this image, with its stubbornness, doggedness and nostalgic appeal. Your Yiddish dialect can be so natural, so much a part of the role of Solomon, that the audience may never think of it as such. They could not conceive of Solomon speaking otherwise. So used, dialect is a means to an important end—the creation of a role that is a true and memorable stage character.

4
NORTH AMERICAN DIALECTS

CD ONE

MIDWESTERN

MIDWESTERN NO. 1

Fishing at Three Fingers Bay, Oklahoma
(Speaker: Leo B. Marsh)
(The portion in parentheses is not heard in the spaced repetition.)

Me friend, you WOHNT me to tell ya where we had our best luck fishin?/ *want*

It was up on, uh, uh, *Gran' River at Three Finngers Bay.*// *fingers*
Mother'n I went up there in the spring,/
and, uh, we fished from a heated dock.//
And the FIRRST fish that Mother caught STARRTED to pull her LAAN,/ *line*
and she STARRTED FOLL'IN the pole like she was gonna walk offa the dock into the river.// *following*
She said, "It's takin' my pole away!"/
'N I said, "Well, you'll have to pull it back in, or he's gonna pull you off into the RII-VER!"///

The most direct ROWT from here to SAALOAM Springs would be to/ *route, Siloam*
take the BAAPASS out to, uh, HAAWAY Number Thirty-three.// *bypass, highway*

21

(And, uh, cross the Verdigris River out by Inola and on up through, uh, Chouteau./

And when you come to the junction of HAAWAY Sixty-NAAN, you TURRN NORRTH,//

nine

till you come to the junction of HAAWAY Sixty-NAAN and Thirty-three,/

Then you TURRN back east again on HAAWAY Thirty-three//

through Grove, Oklahoma, and on up through Oaks,/ and on east on HAAWAY Thirty-three//)

until you get to the Arkansas State LAAN./

And then you're a SHORRT distance over the LAAN: you come to the city of SAALOAM Springs.///

MIDWESTERN NO. 2

The Mule Hunt (Speaker: Mrs. Leo B. Marsh)

entitled

This li'l NOOSPAPER clipping is ENTAATLED/ "Lou Teaches HERRBIE How to Hunt for an Ancient Mule."//

hunting

They were looking for a place to go deer HUNNIN',/ and they drove up to a place the BARRTENDER had told them about, but they saw a sign was all posted with a "No

hunters

HUNNERS" sign.//

This upset them but they FIGGERRED it wouldn't do any HARRM to talk to the old guy,/

so HERRBIE waited in the truck while Lou went up to the house to talk to the owner.//

nice

He TURRNED out to be a helluva NAHS man,/

and Lou asked him about PERRMISSION to hunt on his land,//

and much to his surprise the old man said that they were very welcome./

He said he'd even sold his old gun and in that connection he asked Lou if he'd do him a favor.//

He said he had an ole mule that was just about as old as he was,/

legs

and it was on its last LAYGS.//

Seein' as he had no gun and he couldn't bear to kill the ole mule anyhow, would Lou please do him the favor and do the job for him./

Well, Lou thanked him VERR' much, and he said he'd take care of the mule.///

He then walked back to the truck and HERRBIE WANNID to know what had taken him s'long.// *wanted*

"Oh," said Lou, "AA got into an argument with that stoopid ole man./

"He says we CAAN'T [a] hunt on his property.//

"AA got a good mind to do somethin' to get even with him."/

And at that moment Lou saw the old mule, a really sorry old mess, and he said to HERRBIE, *"AA'm s'mad at that ole man, AA got a notion to shoot his jackass. Gimme that gun!"*//

And HERRBIE was STAGGERRED by that kind of talk and he made no motion to pick up the gun./

But Lou reached into the truck and he grabbed it, and then he loaded it.//

"Damn mis'rble ole man!" he said. "This will even things up!"/

And he TURRNED and FARR'.// (Laughter) *turned, fired*

Oh me! and the old man — and the old mule, drilled through the head, fell dead at his feet./

Well, HERRBIE was HAWRRUHFIED and SCAIRRED,// *scared*

he STARR'D the truck engine, he threw it into gear, and he took off, TARRS a-screamin.'/ *tires*

Lou STARR'D running after him, and yellin'.//

And FAHN'LY HERRBIE, lookin' in the MIRR' to see if *finally, mirror* the old man was chasing him, saw Lou running down the road and sto-stopped to get him./

Lou was laughing s'HARRD that he could HARRDLY tell HERRBIE what the truth was but FAHN'LY he got it all out.//

But HERRBIE tells me that he still has the shakes every time he thinks about that mule.///

MIDWESTERN NO. 3

Grandfather Drives from Arkansas to Oklahoma
(Speaker: Gary Bass)

Well, the STORR' I'm gonna tell y' today is about my, uh, *story* grandfather/

well	when he, when he come over. WAALL now, he was
born in	BORRNN, he was BORRN Arkansas.//
	His family was poor farmers; he used t' tell us how they'd/
potatoes	oh, store P'TAYS in the ground, uh,//
during, winter	store P'TAYS in the ground DERN the WINNER; they'd
furrow, earth	dig a li'l FURR' in the EARRTH n'en jus' put 'em in there/
needed, sort of	and dig 'em up whenever they NEEDD' em; SORUVA, you
a type of	know, portable root cellar; that TAAPA thing.//

So the day that, uh, the day that he was gonna come into Oklahoma, well, he hitched up a wagon with, uh, with muh grandmother;/

he drove that wagon with the two mules on it, and my grandmother,//

and all their, all their belongin's in the backa the wagon,/
he hitched it up, and drove it across the BRI-IDGE,///

| *territory* | *across this railroad bridge; this is the only bridge in the TARE-TORY of which he could get across./* |

And he, it was a, it was a toll bridge.//

It was a toll bridge, 'cause on the other end of the bridge was a toll collector;/

'course he wouldn't have none a' these booths like they have today out on the HAAWAY, but they—//

he had a HAOWSE ('course he was livin' there, I mean that was his HAOWSE, his home)./

And he come out, when he saw muh grandfather crossin' the bridge, and collected the toll!//

And, WAALL, ye know, my GRANDFARR, he didn't recollect nothin' bout THA-AT./

He didn't figger on havin' to pay a toll t' get into Oklahoma!///

MIDWESTERN DIALECT SPEECH: A SPECIAL NOTE

The Midwestern area covers many states. It has a great variety of sub-dialects and vestigial dialects, closely related to each other, varying from south to north and from west to east within the region. (See p. 2.) The items on the CD are from the boundary area between the Midwest and the Southwest, but may loosely be called Midwestern. You may adapt them as described below for specialized dialects of the region when this is necessary, using also the vowel and consonant changes and the colloquialisms and idioms noted as belonging especially to certain areas.

Going northward from the southern border, the speech patterns begin to change. The sustained nasality and the drawl diminish. Southward and eastward, on the Ozarkian plateau, the mountain speech, as Midwesterners call it, hillbilly speech as Easterners think of it, is characterized by increasingly relaxed articulation, a langorous ingratiating quality, blending into the Kentucky-Tennessee variety of Southern dialect. In mountain speech, however, a sibilant *s* is common, "a sound as if your false teeth didn't fit!," as one Ozarkian described it. Much farther to the north, in the Minneapolis area, where a great concentration of people of Scandinavian origins live, a slight tendency toward Scandinavian intonation is common, and the substitution of *yah* or *yuh* for "yes" is general. Eastward toward Chicago a flatness begins, often combined with nasality. It is heard especially in short *a* sounds. In Chicago itself and other northern urban areas, the speech of the uneducated tends to be loud, emphatic, uninflected and sometimes strident, in contrast to the gentle easy intonations of the southern Midwest.

Many variants are common in the extreme southern border of the Midwest and the Southwest. Such are elisions of vowels following medial *r*, particularly in proper names: Dor'thy, Mar' Lou (Mary Lou), Huck-leberr' Finn. First syllables of place names are stressed: KANS's City, GALL'tin (Gallatin), SENT Louis. The place names Missouri, Cincinnati and Ohio are pronounced *Missouruh, Cincinnatuh, Ohiuh*. Note also in Southwestern, *continyuh*, p. 32. For a dialect peculiarly Missourian, Hal Holbrook's record *Mark Twain Tonight!*, in which he successfully attempts Mark Twain's native speech, is a good model for the actor.

Pronunciation Notes

Short vowels *a*, *e* and *i* as heard in the Midwestern items are nasalized and often drawled. Note this also in Southwestern Nos. 1 and 2. Short *a* in "can't" often becomes *ay*; it is frequently respelled *cain't* in dialect plays. In Midwestern No. 2, you hear *laygs* for "legs," which is a related vowel change. "Want" changes to *wohnt*; this vowel change is common in the Midwest, the Southwest and the South. *Set* widely replaces "sit" in all tenses: "Set down awhile." The since/sence, pen/pin double variant extends from the southern Midwest through the Southwest and the South. Long *i* becomes short *a* sustained, or an *ah* spoken with a narrowed mouth opening, the jaw lifted slightly from the *ah* position. The sound is respelled *aa* in the transcriptions to differentiate it from the full *ah*

that the broadest Southern speech uses for the personal pronoun *I* and words having that sound.

A special *r* is heard in this dialect, the typical Midwestern and Southwestern *r*, called by linguists the retracted *r*. It is heard most clearly when it occurs before another consonant, as in *turrn* (Midwestern No. 1). Make this *r* by pointing your tongue tip back as you sound it, holding the position a moment. Use it in elisions around medial *r*, as described above, and as in *furr'* for "furrow."

Middle *t*'s and *d*'s are also elided, especially *t* after *n*, as in *hunners* for "hunters" in the Midwest, the Southwest and the South. *Star'red* for "started," *wann'd* for "wanted," *guunness* for "goodness" are common.

The lists below include a number of changes not heard on the CD, but important to the dialect.

Vowel Changes

STANDARD	MIDWESTERN	
can't	caan't	Short *a*, often short *e* and short *i* also are sustained and nasalized before *n*.
want	wohnt	*Ah* and *aw* become *oh* in "want," "all," and similar words.
line	laan	Long *i* becomes short *a* sustained, or *ah* narrowed.
legs	laygs	Short *e* becomes *ay*.
territory	tare-tory	Short vowels following medial *r* are elided.

Vowel Changes That Are Common,
but Not Heard on the CD

STANDARD	MIDWESTERN	
New York	New Yahrk	*Or* becomes *ahr*, especially in Missouri.
short	shahrt	
sit	set	Short *i* becomes short *e* before *n*, and in "sit" before *t*.
since	sence	
pin	pen	Before *n*, the change takes place in reverse. See p. 25.
pen	pin	
when	win	

Consonant Changes

STANDARD	MIDWESTERN	
turn	turrn	The *r* becomes a retracted *r*. See p. 26.
furrow	furr'	The *r* is retracted and the last syllable dropped.
winter	winner	Medial *t* or sometimes medial *d* is dropped following *n*. (Compare *innerested*, Southwestern No. 1.)
started	star'red	Medial *t* or *d* before final *ed* is often elided.

Colloquialisms and Idioms from the CD and Other Sources

Goin'	G dropped from present participle "ing" endings is typical.
runnin'	
Whatcha doin'?	
Typa (type of)	*Of* is reduced to the *a* in "sofa," "Minnesota."
Backa	
Offa	
Yah, yuh	These are substitutions for "yes," especially in Minnesota.
kin (can)	These vowel changes are restricted to these words.
jist (just)	
melk (milk)	
pore (poor)	
Waall, now	Well, now.
Figure on	Anticipate.
Recollect	Used instead of "remember."
Grampaw, granmaw	Used for "grandpa," "grandma," especially in Missouri and Kansas.

Common Sayings Useful for Improvisations

He still has the shakes.
She's poor as Job's turkey.
We're goin' to a shindig (a party).
He's crooked as a dog's hind layg.

Pronunciation Notes for British Actors

Midwestern speech is the nearest of any to a general colloquial North American speech. Its relaxed style of articulation is common throughout much of Canada and the United States. Medial *t* is regularly *d*. Where British speakers would say, "What a pretty little kitty!" North Americans say, "Whad a priddy liddle kiddy!" Most casual speakers drop the *y* sound of "new"; they call it *noo*, not *nyoo*. Only very careful speakers, proper Bostonians, for instance, might say *nyoo*. "That noo stoodent's quite stoopid" is what a casual educated speaker might say.

Inflection Notes

The slow drawl, rising and falling at the end of the sentence, is the hallmark of this dialect. You hear it in No. 1, in "Three Finngers Bay," "It's takin' my pole away!," "gonna pull you off into the RII-VER!," "collected the toll!." It is not so noticeable in No. 2, probably because this example is read, not improvised; hence it has less vivid inflections.

Practice the inflection sentences even more slowly than they are heard on the CD. Drawl *waall*, *bri-idge* and *ri-iver* as much if not more than in the examples. Try retelling *The Mule Hunt* using more drawl than the speaker.

Character Notes

The rural quality in all three examples, both in content and in style, is the key to the characters of the speakers. Broad country humor characterizes every one, a typical trait. The younger voice in No. 3 would serve well for a cowboy "typa" speech. The Midwestern farmer type emerges clearly in Nos. 1 and 2.

Recordings

The Best of Hal Holbrook in *Mark Twain Tonight!*, Hal Holbrook, Columbia/Sony

Oklahoma! (Original 1943 Broadway Cast), Decca

Plays

Bus Stop	William Inge	Bob, Will, Cherie, Grace, Virgil, Carl
Green Grow the Lilacs	Lynn Riggs	All characters
No Time for Sergeants	Ira Levin	Will, Ben, Pa Stockdale, others
Picnic	William Inge	All characters
The Rainmaker	N. Richard Nash	All characters

Musicals

| *The Music Man* | Meredith Wilson | All characters |
| *Oklahoma!* | Richard Rodgers and Oscar Hammerstein II | All characters |

SOUTHWESTERN

SOUTHWESTERN NO. 1

Trees and Traditions in Texas (Speaker: Maureen McIntyre)

AA'M from Houston, Texas, and AH'VE never had any speech trainin'./

(Really?)

Not a BI-IT.//

(What's it like in East Texas?)

Oh, it's real nice, there are a lot of trees out THAY-ER./

Not too many people, though.//

Tyler, Texas, out there, Jacksonville, those are PRI' big places,/ *pretty*

not too many movie theatres, or anything like that.//

But lotsa NAAS trees, lotsa NAAS trees.///

Well now, I tell you, out in East Texas there are just a lot of things we don't TOL'RATE./

LAAK drinkin', uh, things LAAK that. Most of the KAOWNTIES are DRAA.// *counties, dry*

We have a lot of—a lotta good Baptists,/

and a lotta good Methodists, a lot of religious people.//

And, uh, uh, these people are INNERESTED in their country./

There are a lot of people out in our parta the country who are for *law and OHRDER,*//

if you know what AA mean./

We want things to be *straight and moral* in our parta the country.//

We jist don't TOL'RATE messin' ARAOWND, drinkin';/

that sorta thing is not what our people WOHNT.// *want*

We sincerely believe that with law and *OHRDER/*

this country would improve miraculously.///

SOUTHWESTERN NO. 2

An Architect from the Piney Woods (Speaker: Larry Evans)

Texas	AA'M *from the piney woods of East* TAYKSUS./
	I'd like to talk to you a little bit today on designin' a HAOWSE.//
mainly, start	*The* THANGS *that we wanta look at is* MYNELY, *we'll* STAWRT *with the* KIITCHEN,/
	which is, kinda take 'em down the LAAN of their
expense	EXPAYNSE,//
think	and I THANK this is the best way for us to STAWRT,/
	to STAWRT on the EXPAYNSE side of designin' the HAOWSE.///
	Gonna look at, first of AHLL, in the KIITCHEN,/
major	the MYEJER EXPAYNSES we have, is your facilities, and
place	uh, that you PLYCE in your KIITCHEN,//
	git real expensive, because this calls for so many of these elements in the,/
one	*in this* WAWN *room.//*
trends, bring	We know that today modern TRAY-UNDS BRANG in
microwave	MAACROWAVE ovens,/
scene	which is brand new on the, on the SAYN.//
	We just heard a great deal about 'em just recently./
	And they've finally sealed 'em off now to where they're safe.//
	MAACROWAVES *cause great damage to the human* SKIIN
flesh	*and* FLAYSH;/
	they penetrate deeply; but this has been taken care of.//
	They're safe now for the KIITCHEN,/
	and they're bein' mass-produced under close gov'ment supervision.//
things	These THANGS are very important, and to make 'em safe like THI-IS.///
	We WOHNT to look also at what goes into the KIITCHEN,/
	your design specially;//
	and one THANG for you LYDIES to check over is the design elements of your three WURRK,/
	of your three areas that you're involved with.//

MYNELY this is around your REFRIGERYETOR, your stove and your SI-INK./

Now this distance forms up a TRAA-ANGLE.//

And that should be a distance of THIIS TRAA-ANGLE of twenty-WAWN feet and no MOHWER./

If it's any MOHWER than that, reject the HAOWSE, or redesign your KIITCHEN.///

SOUTHWESTERN NO. 3

Texas Has a Problem (Speaker: Brenda Keith)

AA'M from Alvin, TAYKSUS, which is about twenty miles SAOWTHA Houston./ *south of*

And I'd like to talk to you T'DYE about the problem of juvenile DELIINQUENTS.//

One of the biggest problems is that people, uh, *refuse to get involved,/*

unless, uh, it involves them personally, like if their children are juvenile DELIINQUENTS.//

NAOW, the facilities in the STYTE uh TAYKSUS, such as STYTE homes, are very few; we have, AA'M not sure HAOW many in TAYKSUS,/ *state*

but we have very few STYTE homes for DELIINQUENTS in TAYKSUS.//

And, uh, JIST for example, from WHAR AA'M from, DAOWN THAYER,/

we have no juvenile home//

because our KAOWNTY isn't big enough,/ *county*

and the only facilities we have are two SAY-ULLS in the *cells* KAOWNTY jail,//

which is not the proper environment for these people.///

Pronunciation Notes

Examples Nos. 1, 2 and 3 are from "deep East" Texas, where the Southwestern dialect is very strong. The vowel changes listed below do not occur in all three examples. Decide which ones you will use according to how heavy or light a Southwestern dialect you will assume. In the last two examples, though the topics are sophisticated, the dialect is heavy—a sign of authenticity.

Vowel Changes

STANDARD	SOUTHWESTERN	
Texas	Tayksus	Short *e* becomes *ay*.
expense	expaynse	Short *e* becomes *ay* nasalized.
cells	say-ulls	Short *e* becomes *ay* drawled.
state	styte	Long *a* becomes long *i*.
house	haowse	*Ow* becomes *aow*, practically standard.
I'm	Aa'm	Long *I* becomes short *a* sustained, as in Midwestern.
one	wawn	Short *u* becomes *aw*.
thing	thang	Short *i* in *ing* becomes short *a*.
where	whar	*Whar* is more an idiom than a word with a dialectal vowel change.
there	thayer	The vowel in *ere* becomes *ay-er*.
want	wohnt	See Midwestern vowel changes.
more	mohwer	*Awr* becomes *oh-wer*.

(The changes below are very common. They are not present on the CD here.)

do	dyoo	*Oo* becomes *yoo*, often spelled *iu*.
continue	continyuh	The last vowel is typically relaxed. (Compare the note on p. 26.)
since	sence	See Midwestern vowel changes, p. 26.

Consonant Changes

STANDARD	SOUTHWESTERN	
interested	Innerested	Middle *t* is dropped after *n*.
Work	Work	*R* is usually retracted *r*. See Midwestern consonant changes.

Colloquialisms and Idioms

Colloquialisms are frequent and are much the same in the Midwest and the Southwest. "Designin'," "bein'," "kinda'" are typical. Idioms heard on the CD are: "tol-rate," "whar A'am from," "daown thayer." "Aa reckon," not heard on the CD, is common.

Inflection Notes

The inflections are vigorous and assertive. The drawl is much less pronounced than in Midwestern. It occurs within the word, as in *bi-it*; the author has heard it in Texas in *ye-es*, and in *wo-ould*. Note the lack of drawl in the negatives "not what our people want," "reject the haowse or redesign the kitchen," "not the proper environment for these people."

Character Notes

The characters seem rural-into-urban types, who have brought their rich regional dialect into their professional lives. The dialect can be adapted to many character roles. The genuine nature of Southwestern No. 2 makes it especially valuable for rural Western dramas.

Recording

LBJ, Lyndon Baines Johnson, Jerden Records

The late President Johnson's speech on the Voting Rights Act is a good
source of sophisticated Southwestern speech. It is completely understandable but recognizably Texan.

Plays

All the King's Men	Robert Penn Warren	Willie Stark, Anne Stanton, others
The Great American Desert	Joel Oppenheimer	All characters
Indians	Arthur Kopit	Buffalo Bill, Wild Bill Hickok, Annie Oakley, Jesse James, Billy the Kid, others
Macbird	Barbara Garson	Macbird, Lady Macbird
Of Mice and Men	John Steinbeck	All characters
Operation Sidewinder	Sam Shepard	Billy, Dude, others
The Trip to Bountiful	Horton Foote	All characters

Musicals

Annie Get Your Gun	Dorothy and Herbert Fields, Richard Rodgers and Oscar Hammerstein II	Annie, Frank, Buffalo Bill, Pawnee Bill, others

SOUTHWESTERN NO. 4

(Nos. 4 and 5 form a West Southwestern group.)

Horror Movies in Albuquerque (Speaker: Raul Huerta)
(The Spanish phrases are respelled phonetically. The correct
Spanish spelling follows the respelling.)

barrio In Albuquerque there is a uh, a varrio./ A varrio is a neigh-
borhood.//

And in this varrio, on Sundays, there were two KEEDS,
two KEEDS, very, very good friends./

One's name was Jesus, but everybody called him Jesse.//

Anyway, this friend of mine, Jesse, Jesse and I would call
each other on the phone,/

"Hey MA-AN! Where do you want to go today?//

"Want to go to the State or La Kimo?/

"Or what show do you want to go see?" And then we
would decide.//

horror Sometimes we would go to the HORR' movies./

We really liked—the place we really liked to go to though,
was La Kimo.//

La Kimo was the neatest theatre in all of Albuquerque,
you know what I mean?/

We would go there; we would wait outside, you know,//

never 'cause they ne—it's all little KEEDS, you know, all those
little,/

you know, these little pachucos[b] from all over the place,
you know;//

and then we would go in the theatre.///

That theatre was crazy, man; it was really scary, because

chairs you would sit in the SHARES upstairs,/

you would sit in the SHARES;//

and then they would have the lights on already!/

And the lights would come on, and there were these buf-
faloes, man, I'm telling you!///

Buffalo heads, they had these buffalo heads,/

and they used to scare me, man!//

And we used to sit there and laugh, and it would really
scare us./

And that's where they did House on the Haunted Hill.//

I'll never forget it; *we went to see House on the Haunted*
Hill there, and then they had this skeleton!/

It came down in the middle of the show, and everybody started screaming,//

KEEEEE! MEE-RAH!/ (*Qui mira*, look at that.)

That's the way people speak Spanish there, you know.//

Be like, *hey MA-AN! AH-DOH NAY VA-AHS!/*(*a donde vas*) which means, Hey, where are you going, you know.//

Or, hey MA-AN! KESTUHSOHS EN DOH?/ (*que estas asiendo*, What are you doing?)

You have to say it like that. 'Cause if you said it,//

Hey man, KESTUHSOHS YENDO?/ (*que estas asiendo?*) like that is the way you should speak Spanish.//

But, man, we didn't speak like that. We had a ways of sayin', you know,/

HEY MA-AN! KESTAHSUS YENDO? You know, like that.///

SOUTHWESTERN NO. 5

Mexican English (Speaker: John Peters)

The ESPRESSION Cuentas claras y chocolate espeso,/ *expression*

the Mexican people have this ESPRESSION, which says, which says,//

THEES EES what all Spanish people say, by the way, in ENGLEESH,/

it says, Clear decks and THEEK chocolate.ᶜ///

EES a very nice THEENG to *HAHVE* you know, especially if you are LEEVING in Mexico SEETY,/

where there is so many FORAN peoples,// *foreign*

that you can show them to the way to the bull fight,/

and you can tell them to take a TREEP to *WAH-DALAHARA* *Guadalajara* or to *WAH-HAHKA.*// *Oaxaca*

I — I am trying to tell you that the Mexican people have a DEEFFERENCE for the musical way/

to end the sentence so that you know that EET'S Mexican.///

SOUTHWESTERN NO. 6

Life in Juarez (Speaker: Jacqueline Margolis)

Mehico EES a place WEETH very much ACTEEVITY,/

and there's all sorts of things HAPPENEENG.//

There are very many people in Juarez, ZEES EES,/
which is close to El Paso, TEHAS.//
And the people are all sorts of DEEFFERENT types, and they all,/
they WORRK mainly in labor in El Paso, because the jobs are good.//
They usually HAHVE a very BEEG family,/
because, THEES EES, *I guess, nothing much better to do!//*
But I THEENK, you know, the people have a lively STHRENGTH in their RELEEGION,/
and everything that is so good to HAHVE.///

Some Spanish Words Common in Mexican English (Speaker: Judith Sanchez)

NORREDE AMERICANO (Norde Americano)
LOS ANHELES (Los Angeles)
BEDTHRO (Pedro)
GREENGOHSS (gringos)
KAHVAHYEEROES (caballeros)
AHMEEGO (amigo)
BURROS (burros)
TORTEEYUHS (tortillas)
SENORRITA (señorita)

Pronunciation Notes on Southwestern Nos. 4, 5 and 6

These three examples are closely related to Spanish as heard in Mexico. No. 4 is an example of Chicano speech, Chicano being a term for one born in America to Mexican parents. The speech is vivid, extremely colloquial, a mixture of slang, substandard sounds and Mexican-Spanish tags. Nos. 5 and 6 are quite different, being Mexican dominated. No. 6, the heavier of the two, is typical of the dialect heard at the border, where El Paso in Texas is neighbor to Juarez in Mexico.

The list of names and nouns following No. 6 gives you the pronunciation of some common Spanish words as pronounced in Mexico. They provide accurate and useful instances of Mexican variants. Listen carefully to the *rd* in *Norde Americano*. The *r* is trilled, but with the tongue tip well back in the mouth. The *Norde* is close to *Norruhde*, as if an extra syllable were added. Similarly, *Margharita* would be *Marruhgarita*; *garbanzos* (Mexican beans) would be *garruhvahnzoes*. Listen to the *dr* in *Pedro*. The *d* is dentalized low, the tongue tip touching well down on the inside of the upper teeth. Combined with *r*,

dr gets close to *dthr*. This is because in Mexican dialect, as in Spanish, the tongue tip in making contact for *d*, *dr*, *t*, and *tr* moves visibly low and forward toward the parted teeth. Likewise the low tongue changes *b* to a relaxed *v*, and double *l* to *y*. Compare the notes on Spanish accent, pages 135 and 136.

Vowel Changes

STANDARD	CHICANO AND MEXICAN SOUTHWESTERN	
kids	keeds	Short *i* becomes *ee*.
Man!	Ma-an!	The vowel is drawled.
have	hahve	Short *a* becomes *ah*.
Oaxaca	Wah-haka	*Oa* in initial position becomes *wah*.

Consonant Changes

AS SPELLED IN SPANISH	AS PRONOUNCED IN MEXICAN	
barrio	varrio	*B* becomes a relaxed *v*.
tortillas	tdorteeyuhs	*T* is dentalized low; double *l* becomes *y*.
Pedro	Bedthro	*D* is dentalized low; followed by *r*, it gets close to *dthr*. See also *sthrength* (No. 6).
Texas	Tehas	*X* becomes *h*.
Oaxaca	Wah-hahka	
Guadalajara	Wahdalahara	Initial *g* is silent. *J* becomes *h*.

AS SPELLED IN SPANISH	AS PRONOUNCED IN MEXICAN	
Juarez	Huarez	*J* becomes *h*.
burro	burro	Medial *r* is strongly trilled, with the tongue tip well back.
Norde	Norrede	*R* before a consonant is trilled far back and lengthened; almost *Norruhde* (three syllables).

Changes in English Words Not Heard on the CD

is	ist	What ist a time?
Hello!	Ello!	Initial *h* is dropped.
How are you?	Ow are you?	

Character Notes

The Chicano and Mexican types calling for these dialects are easily recognized. The rough quality of the Chicano, minus the Spanish tags, would serve for some TV Western drama types. In plays like *The Portrait of Angelica* by George Ryga, as in most plays with English-speaking and Mexican characters, the Mexican speech contrasts strongly with that of the Canadians and Americans, and there is abundant use of Mexican-Spanish words.

Since Spanish is the basic language of Latin America, the Mexican-Spanish speech may be useful for roles in some translated plays based on other Latin-American countries, as Argentina, where lately there has been a great resurgence of theatre. However, if the performance is for an audience familiar with Argentine English, it would be necessary to find some speaker of that accent, or some recording providing it, as a basis for study.

Plays

The Ballad of the Sad Café	Carson McCullers and Edward Albee	Most characters
Camino Real	Tennessee Williams	Rosita, Abdullah, all street characters
Indians	Arthur Kopit	Indians
The Portrait of Angelica	George Ryga	Mexicans
A Solid Home	Elena Garro	Mexicans
Sunday Costs Five Pesos	Josephina Niggli	All characters

SOUTHERN

SOUTHERN NO. 1

The Right Way to Serve Grits[d] (Speaker: Florence Trawick)

Prattville I was born in PRAHTVILLE, Alabama, a small TAOWN a little ways out of Montgomery./

I wuz — it was in nineteen-FORDY-TYOO, and I've lived there all my life.//

My father's from Greensboro, Alabama, the heart of the Black Belt, and a wonderful old place./

soil My father has cotton, and raise — has a dairy; besides this he works in Montgomery for the SOHL Conservation Service.//

(The spaced section on the CD begins here.)

Ah, grits, to so MEH-Y people are not the most *many*
pleasant thing in the worl', but I like them very much./
I think I always liked 'em on Sunday mornin's, because
there was plenty of time to really enjoy EA-ING//
the eggs and grits and HA-AM and so AWN./
And I know when I've met people from all ov' the United
States,//
When AA was at college, people would say, "GRI-ITS!
that's just the worst thing in the worl'!"/
And I would have to explain to 'em that they don't know
how to put salt and pepper and butter in 'em.//
They just stop with GRI-ITS;/
and that's what really makes them so good.//
I must say I'm not the most ATHALETIC thing; I think
I'm the most indoor thing;/
but one thing AA do LAAK to do is, AA LAAK to sew
very much.//
I'm not TYOO much on cooking, but throughout
HAA-SCHOOL, I enjoyed doin' my own, makin' my own *high school*
clothes.///

SOUTHERN NO. 2

A North Carolina Citizen Faces a Problem[e]
(Speaker: Philip Howerton)

MAA personal feeling is this, uh,/
and AA think it goes back to possibly TWENNY-FAAV
years ago,//
when as an elder in the First PREB'TERIAN Church,/ *Presbyterian*
we AWN the Session voted at that TAAM to instruct *on*
AOWER *ushers//*
that if a NIGGRA presented himself for that SARVICE,
that he was to be seated/
WHAREVER *he* WANNID *in the* CORR'GATION.// *congregation*
So MAA first reaction when these SIDDOWN strikes came
along was/

that if the merchants had at that TAAM immediately served the NIGGRAS,//

the whole thing would have gone up in smoke,/

and in two or three days it would have all been settled and forgotten.//

Now AA can see a good deal of argument in the NIGGRAS' position./

And if AA were one of them AA might say that AA might be right along with them.//

(Well now, what happened here in Charlotte, as the thing was worked out? It was settled here in Charlotte?)

VAIR' peacefully./

(Do you feel then that the movement which seems to be taking place in some places for better employment opportunities for Negroes is in the right direction?)

AA CERT'NY do, CERT'NY do.///

SOUTHERN NO. 3

The New Southern Belle (Speaker: Kathy Swan)

AA'D just like to say a few words right here and now about this notion of the Southern GENNELWOMAN./

Now AA'M not all turned on by Women's Liberation or anything, AA mean,//

AA like a man to be strong, and AA like to lean a little./

But AA don't mean bein' some KAAND of clingin' VAAN!///

I think we girls should have a little independence TYOO.///

AA mean, what happens if your husband up'n DAAS, or somethin'?/

Or injured; and then there's that rehabilitation TAAM.//

Or if you get divorced, well, AA think alimony is just blood money./

AA would not take it!//

Well, all Aa'm saying is the *day of those pretty little white dresses/*

and the mint julep on the front POH-UTCH of the KAINTUCKY mansion,//

well, they are gone, honey, they are just gone.///

SOUTHERN NO. 4

Raising Pets and Children in Alabama
(Speaker: Shelia Russell)

My father loves pets, and so does my mother, and so,/
In my fam'ly there are eight KI-IDS, there are eight children, counting myself.//

And Daddy has taught us to treasure the fact that we can raise and make PE-ETS, animals, multiply in captivity./
We like to have rabbits for PE-ETS, but not in cages;//
they can stay inside the fence at HO-OME, and we can call and make sounds that they can come.///

Well, eight children in my FAM'LY,/
one pet apiece is eight THAY-UH.//
We never get one of a type./
Daddy says if you get one dog, you get two; if you get a bird you get two birds;//
because he thinks it's cruel to get, to get one of any TAAP animal./
So, if each CHAA-AHLD has one pet, it has to have a MAY-AYTE; well then, that's sixteen THAY-UH.///

Pronunciation Notes

Southern speech is very variable. The examples on the CD are midway between heavy and light Southern accent. Usually a very deep Southern dialect is not necessary on the stage. The original production of Lillian Hellman's *The Little Foxes*, which the author saw on Broadway, used a light Southern quality. The deep South quality, heard when Marc Connelly's *The Green Pastures* was on the stage some time ago, is out of style now, particularly with black actors.

The most important vowel change is the change of long *i* to *aa* or *ah*. (See the notes on this sound in Midwestern and Southwestern pronunciation notes.) Southern speakers use either *aa* or *ah* wherever long *i* occurs, but especially in the personal pronoun. The examples on the CD vary. Observe and follow them closely as you play and say each one.

Southern speech particularly substitutes *oh* for several vowels, as do Midwestern and Southwestern to a lesser degree. It is clearly heard in *wohnt* (want), *moh-wer* (more), *kohs* (course), *ohl* (oil). *Oy* as *oh* is unmistakable in No. 1, "the *sohl* conservation service."

Ow becomes *aow* almost universally in the South, for educated and uneducated speakers. "Can't," widely spelled *cain't* in Southern

literature, would be *caynt* in our respelling. See *laygs*, Midwestern. "Two" and "do" are generally pronounced *tyoo* and *dyoo* in the South and sometimes the Southwest.

As to consonants, middle *t* is dropped from "twenty," again as in the Mid- and Southwest. *R* is dropped from a word like "sir," as in British English. But the Southern vowel is quite different. It is a neutral short *u*, almost *ah*. The respelling is *suh*.

Drawling of vowels and slurring of syllables are so important to Southern speech that lists of typical drawled or slurred words have been added to the vowel and consonant change lists. Practice these, using drawled inflections like those you hear on the CD.

Vowel Changes

STANDARD	SOUTHERN	
I	Aa or Ah	See note above.
soil	sohl	See note above.
too	tyoo	*Oo* changes to the first vowel in *music*. The respelling in plays may be *tiu*.
how	haow	*Ow* becomes *aow* consistently.
can't	caint	Short *a* becomes *ay*.
there	they-uh	*Air* becomes *ay-uh*. (Compare Yankee.) *R* is dropped as part of the change.

Consonant Changes

STANDARD	SOUTHERN	
twenty	twenny	See note above.
sir	suh	*R* is dropped; *er* becomes *uh*.

Drawled vowels are usually nasalized and spoken with a falling inflection.

grits	gri-its
good	go-od
ham	ha-am
home	ho-ome
pets	pe-ets
porch	poh-utch
there	thay-uh

Slurred syllables drop middle t and reduce other consonants. The elision may be considerable, involving entire syllables. (Compare Southwestern.)

certainly	cert'ny
congregation	corr'gation
eating	ea'ing
gentlewoman	gennelwoman
many	meh-y
Presbyterian	Preb'terian
wanted	wannid

Colloquialisms and Idioms

These are numerous. In addition to those heard on the CD and listed below, a special list of idioms from the deep South of Mississippi has been added to help you in improvisations that might need them.

Niggra for the less liberal Southern white is a compromise term between *nigger* and "Negro." *Honey* is a casual form of affectionate address. You hear a rich drawl on this word in Black American No. 3.

STANDARD	SOUTHERN	
mornings	mornin's	*Ing* is regularly reduced to *in'*.
make them	make 'em	The *th* of *them* is often dropped.

Idioms Heard on the CD

STANDARD	SOUTHERN
Negro	Niggra
A little way	A little ways
athletic	athaletic

Idioms of the Deep South

Particularly of Mississippi, these idioms are used and pronounced alike by both black and white speakers.

Lawd, honey!	An exclamation.
Shoh 'nuff, honey?	You don't say? (American); really? (British).
Shoot, honey! 'S not all *that* impohtant.	An expostulation.

Ma'am? Suh?	The equivalent of "Pardon me?" (American) and "Excuse me?" (British).
Ma'am	Used as a term of respect to a woman, old or young, familiar or a stranger. "Marry me, Miss Mary, ma'am?"
Carey (carry)	Drive. "Y'all don' walk, George'll carey yuh t' church."
Y'all	You.
Y'all hurry ba-ack naow!	Come back soon!
Y'all don' wanna do tha-yut.	Please don't do that.
G'wan up in the house.	Go into the living room (from the kitchen).
Hah yuh doin', sugah?	An ordinary greeting.

Some typical inflections of the above:

```
Lawd                        ey'
        ey!      'nuff, hon-        am?
    hon-   Shoh              Ma-

        don'            tha-
    Y'all      wanna do      yut.
```

Character Notes

The speech of Nos. 1 and 4 is right for the Southern ingenue, types like Frankie of *The Member of the Wedding*. The speech of No. 3 is more that of the traditional Southern belle, in spite of the content. The speech of Philip Howerton of No. 2 is right for the Southern business-man or politician or similar roles.

The inflection is important to the characterization. Reproduce it fully as you work with the CDs. Keep the accent as a whole light; it easily slips over into phoniness. A slight but constant drawl, ending in a rise in pitch; a noticeable slurring or elision of middle syllables of long words; and a change of the vowels long *i*, *ow* and *aw* may be all you need.

Recording

The Sit-in Story, Folkways Records
(This is the source of example No. 2. Other voices on the record are also
 useful. Secure the recording and listen to them all.)

Plays

Cat on a Hot Tin Roof	Tennessee Williams	All characters
The Glass Menagerie	Tennessee Williams	Amanda
The Little Foxes	Lillian Hellman	All characters
The Member of the Wedding	Carson McCullers	All characters
A Streetcar Named Desire	Tennessee Williams	Blanche, Stanley, Stella, others
Tobacco Road	Jack Kirkland	All characters

Musicals

Regina	Marc Blitzstein and Lillian Hellman	All characters

NEW YORK-BROOKLYNESE

NEW YORK-BROOKLYNESE NO. 1

In a Brooklyn Bar (Speakers: Frank Cass, Frank Zito)

Hello! Now we happen to be at the Hickory Q DIS evening./

I met a PRIDDY young lady here with two GENNEL-MUN, an' they asked me to speak into DIS mike.//

But I DIN' have much I could really say, except that it's a rotten evening, rainin' like hell outside./

And now I TOIN you OVUH t' the BAHTENDUH, *turn*
Mr. Frank Zito.//

Hel-lo! How's every LIDDLE thing? You like that?/
(Yeah, that's class, you can always tell class.)
UM the PRUHPRYER this place. MAH'V'LES, isn' it?// *proprietor*
Now I'm startin' tuh, I dunno WUT the hell t' say./
(Tell 'em what you owe 'em, what you owe out. You're the proprietor.)
I owe out eighty thousan' DAHLLUHS — they're tryin' *dollars*
tuh collect. NEVUH make it! (Laughter.)///
I lived in BAWLEEMAW, 'n I usetuh drive a KEB, 'n they *Baltimore, cab*
knew I wuz a NOO YAWKUH by my DRESS,/
the SHOIT, the typa SHOIT you wore,// *shirt*
(Black SHOIT'n white trousers.)

Someone jus' spoke 'n he NEVUH shoulda spoken./
He's gonna get hit!//
That's it. GOO'NIGHT!///

NEW YORK-BROOKLYNESE NO. 2

The Part-time Barmaid (Speaker: Myra Zito)

I come from NOO YAWK,/
I'm born here in Brooklyn.//
I work here part time, three days a week,/
I'm mother of four children.//
My oldes' is fourteen, my younges' is seven./
wants to Oh, I have one that WANTSUH be a dentist.//
The OTHUH'D like to be a physical ed. teacher./
The LIDDLE one wants tuh be a MOTHUH.//
The other one's GUNNA be a baseball player.///

NEW YORK-BROOKLYNESE NO. 3

Two Ways to Make a Living in New York
(Speakers: Dorothy Meyer, Robin Brecker)
(The spacing should be followed for each speaker separately.)

She: Yuuh know, that Sanitation Department, they make
so much money now, and I've got garbage on my street all the
time, I mean all the time!/
He: Well, they're, they're nice people; because I have a
relative who, he works, actually he's in Yonkers./
But he gets all his things, yuh know, that people throw
away, that he gives as gifts to other people,//
like a nice table he gave these young marrieds, a dining-
room set, yuh know!/
She: Do they just give him the stuff?//
He: Well, they just TROW it out.//
And yuh know, some people—what's one man's jewel is
another person's TROWAWAY./
She: Yeah, this is true, especially if you work in a high-
class neighborhood./
He: Yeah, people go around, there is a guy who goes
around to celebrities and pickin' in their garbage. Did you
read about that?//
She: No, tell me.//

He: Yes, to—to Neil Simon, and picks, and sees, Bob Dylan,/

and these guys, he, uh, made a livin' by pickin' the garbage, n' seein',//

She: I bet they have some kind of garbage!/

He: Everyone has the same kinda garbage. Garbage is garbage, yuh know./

Well, yuh think they got money in the garbage?//

They got better KAWFEE grounds, that's all!/ *coffee*

She: Oh yeah? The thing is, it's just like the garbage men are prima donnas.//

Yuh know what I mean, like, they won't even come in and get it any more. And they're gettin' paid.///

He: They got to make a livin'; everyone's got to make a livin'.//

She: Oh, this is true, this is true; I don't begrudge them their livin'./

He: My BRUDDER-in-law, he drives a cab in New York, and yuh know, he zooms on as miserable as the next guy;/

but he's got to make a livin', yuh know, and the rates go up,//

but he still, he's gonna drive till he stops drivin'./

She: Yeah.//

He: Yuh know, that'll be forever, maybe.///

She: I've a lot of friends who've driven kebs in the city, and — /

well, you know, like the way when I drive in the city, which isn't too often, but, you know, when I do,//

Oi am afraid of those kebs! Because of the way they zoom-zoomzoom./

He: But yuh gotta, yuh gotta see, yuh gotta keep goin',/

you can't stop, just keep on goin', don't look to the side (She: I know!), just keep on goin'.//

Yuh gotta, you know, there's a trick in the city with the traffic lights;/

that's if you go a certain amount of miles per hour, TWENNY-eight miles per hour,//

She: They all turn for yuh!//

He: Right, 'cause they're synchronized, right? Then you just, why, you just can coast right down,/

go up, or down, dependin' on which way you're goin', yuh know.//

start

She: It's true, it's true.///

He: Yeah, but like, you know, you see some guys, they STAR', they go fast,/

'n they have tuh stop—they go fast again, 'n they have to stop again.//

I have a sayin', everything equals out at the stop sign.///

Pronunciation Notes

New York-Brooklynese dialect is relaxed as to articulation, vigorous as to communication. Match the rhythm, tempo and stress of each example. Run the syllables together as the speakers do, especially in No. 3. But keep the articulation sharp enough so that your audience can understand your every word.

Vowel Changes

STANDARD	NEW YORK-BROOKLYNESE	
turn	toin	Do not depend only on the respelling; imitate the sound on the tape.
cab	keb	Often nasalized, as are other short vowels.
I	Oi	An occasional substitution.

Consonant Changes

STANDARD	NEW YORK-BROOKLYNESE	
bartender	bahtenduh	Silent *r* is frequent in *ar* and *er* syllables.
proprietor	pruhpryer	Middle *t* is dropped, and the *prye* sustained.
throw	t'row	Frequent, but not invariable.

Colloquialisms and Idioms

The style itself is colloquial, free and easy, full of slurred consonants and blurred vowels. The idioms, expletives and profanities that often spark New York street speech are absent here. If they occur in roles you are working on, give them some of the punch and drive and threat of No. 1's "He nevuh shoulda spoken. He's gonna get hit!"

Character Notes

Three levels of social status are evident in the speech examples on the CD: that of the bartender and barmaid; of the cabdriver's

brother-in-law; and of the suburbanite housewife. The differences between them are slight; they merge into each other, with the suburbanite's speech only a little better articulated than the rest. Together they may be considered as prototypes for the speech of innumerable working nonprofessional New Yorkers—salesgirls, truck drivers, janitors, cops, toughs. Use the speech of any one that seems close to the New York type you will play.

Recording
Guys and Dolls, original cast, Decca

Plays

Birdbath	Leonard Melfi	Velma
Dead End	Sidney Kingsley	Most characters
Detective Story	Sidney Kingsley	Most characters
Having Wonderful Time	Arthur Kober	Fay, Barney, others

Musical

Guys and Dolls	Jo Swerling, Abe Burrows, Frank Loesser	Nathan Detroit, Sky Masterson, Adelaide, all street characters

BLACK AMERICAN

(For contrast, this dialect is followed by black African.)

BLACK AMERICAN NO. 1

Tripping (Speaker: Larry Roland)

You know, wishin', and things like that, that's the only TAAM black people imagine things, when they want to wish for SUMPIN', you know?/

Like, uh, say, this drug thing, with the LSD, and trippin', and all that.//

Now, I've found that a lot of black people don't trip,/

I mean, you know, like take these hallucinogenic drugs, such as, you know,//

LSD, T-Ace, all that, alphabet drugs, you know! (Laughter)

I do' know what you call 'em./

*Black people are already faced, like they are already trip-
pin' through life!///*

*You know, they don't need no drugs—we are already trip-
pin'./*

Some of this shit you see out HEAH on the streets.//

This shit is a trip, MAAN!////

boy

BAWEE, like, just the thing that the man is puttin' you
through is a trip./

You know, like watchin' TV; TV is a trip; TV is a trip.//

Listenin' to the radio is a trip; even a black station./

*Dig on how they'd be announcin' things. You know, like,
you have the music AWN,//*

playin' real nice or SUMPIN', you know./

Right after the music this man come on radio, shoutin'
bout' SUMPIN' he's goin' t' sell,//

store

and the nigger don't even own the STAWUH./

"Shop at Summerfield!" "Buy this!" "Half off!" "Easy
credit!" you know.///

BLACK AMERICAN NO. 2

Roller-skating in Boston (Speaker: Sairy Guinier)

Uh, I want to talk about Alfré, because that's the best thing
that happened to me since I came to B.U.,[f] meeting Alfré./

Because, you know, she's crazy, you know!///

And like we, we, like one time we were roller-skating,/

you know, down Commonwealth Avenue;//

and we, you know, we just have a lot of fun together, you
know,/

and I miss her this week, you know, she went away.///

But we've had some very good conversations,/

and I think that we've gotten to know each other as people,
you know,//

uh, very, very well.//

I don't know, it's just she—she's so lively!//

And you know, we fool around, and stuff like that, you
know./

That's the best thing, I guess, that's happened to me since
I came here.///

BLACK AMERICAN NO. 3

Sheila's Church
(Speakers: Brenda Davis, Alfré Woodard and Janet Wardham)

Oh, I gotta tell you about the—did I tell you about Sheila's church?/

O.K., O.K., yeah, we know that you've been in the East for two years now, and *you rattle, but talk slow like people do in FLAWRDUH.//* *Florida*

O.K., I'll try tuh TAIL yuh./ *tell*

Now, HUUN-EE, what yuh got tuh TAIL me? CHAHL,//

Wait, let's do this TAHGAYTHUH./// *together*

I went to this church, y'know,/

this was, it's like, you know, these sanctified churches,//

that's what they call 'em, WHAR AA come from, that's what they call 'em,/

and—well, like, you know, people (oh yeah?), yeah.//

You know, but they, they really have a good time,/

'cause they sit around, you know,//

'n, like the music starts goin', you know, and the drums,/ (uh-huh)

An' they start playin', 'n beatin' on the drums,//

'n EV'YBODY, every OTHUH person had a tambourine, I know, y'know!/

And so then THUH AWGN! Man! That dude would jam it up SUMPIN!// *organ*

I'm tellin' you, he was so BA-AD!////

BLACK AMERICAN NO. 4

Black Woman, a poem by Don L. Lee
(Speaker: Ellis Williams)

Black woman will define herself naturally./
Will talk, walk, live, and love her images.//
Her beauty will be./
THUH only way to be is to be.//
Black man, take her./
You don't need music to move.//
Your movement toward her is music./
And she'll do more than dance.///

Pronunciation Notes

The black quality of the pronunciation is not in the vowel and consonant changes. These are few, and vary from example to example. They are only residually Southern. It is the inflection patterns, half drawled, half energized, that give the speech its modern blackness. The articulation is clearer, more vigorous and less slurred than New York-Brooklynese.

Vowel Changes

STANDARD	BLACK AMERICAN	
child	chahl	*I* in "child" is broader than in "time."
time	taam	
man	maan	
boy	bawee	
on	awn	
honey	huun-ee	
tell	tail	

Consonant Changes

STANDARD	BLACK AMERICAN	
wishing	wishin'	The substitution of *in'* for *ing* is consistent.
store	stawuh	Silent *r* is frequent, as in both Southern and New York-Brooklynese.

Colloquialisms and Idioms

The style of these examples varies, and hence so does the degree of colloquialism, strongest in No. 1, most Southern in No. 3, least and lightest in Nos. 2 and 4. The idioms are mostly the same as those of young urban casual speech: dig on; Man!; she's crazy, you know!; jam up; trippin'. Playing and saying the examples, get the inflections of these idioms with the greatest possible exactness.

Character Notes

No. 1 is an excellent model for the speech of an easy, wryly humorous, realistic-minded black man. No. 3 is full of Southern overtones and will serve for the black who is still close to his origins in the South. A heavier Southern quality is rarely appropriate, except for revivals of

plays like *The Green Pastures* or the nineteenth-century melodrama *Forest Rose*. By contrast, the speech of Nos. 2 and 4 is that of the young educated black, differing from standard American only slightly. The warmth and gaiety of the speaker of No. 2, and the resonant, expressive tones of the speaker of No. 4 are subtly but characteristically black.

Plays

A Black Girl	J. E. Franklin	All characters
The Green Pastures	Marc Connelly	All characters
Lilies of the Field	F. Andrew Leslie	Homer Smith
No Place To Be Somebody	Charles Gordone	Gabe, Johnny, Evie, Cora, Melvin, Sweets, others
Purlie Victorious	Ossie Davis	Purlie, Lutiebelle, Gitlow
A Raisin in the Sun	Lorraine Hansberry	Ruth, Travis, Walter Lee, Beneatha, others
Wedding Band	Alice Childress	Julia, Teeta, Lula, Fanny, others

Musical

Purlie	Ossie Davis, Peter Udell, Gary Geld	Purlie, Lutiebelle, Gitlow, others

BLACK AFRICAN

BLACK AFRICAN NO. 1, NIGERIAN

A Poor Man Is a Snake (Speaker: Ola Rotimi)

> "Song of a Poor Man"/
> *Give me a CHEE-AH,//* *chair*
> *Let me sit in your midst and praise POVARTY and* *poverty*
> WAANT./ *want*
> The face of a poor man stays all crumpled up,
> By reason of the hunger and thirst which are in his
> stomach.//

eat A poor man knows not how to ITT with a rich man.
 When he starts ITTING fish, he ITTS its head./
 Go and invite him who HAHS no bread to come and ITT
crumbs CRUMPS and thorns in their platters.///
is, because The poor man ISS nobody BEECOSS he ISS nothing.
born Though nobly BONN, he ISS granted no favor.[g]
 A poor man is a snake./
 His brothers avoid him BEECOSS of the misery of the
 POVARTY-stricken.//
leads *But when a poor man ISS ill, it LIDSS his people to show*
 him kindness./
 When a rich man is ill, to light a lamp, he must wait for
slave *a SLAYF.///*

BLACK AFRICAN NO. 2, RHODESIAN (SHONA)

Jaha Rinoputa (*The Smoking Gentleman*)[h]
by Edgar Musarira (Speaker: Aaron Hodza)

> Tarisa uwone
> Jaha rinoputa/
> Kwee! rinobakidza//
> Mudzanga Wesitavesendi./
>
> Utsi unoneka kuti
> Mudenga toro// pwititi///
> Iro ronyemwera Jaha/
> Huu! Kunaka, rinodaro.//
>
> Tarira rodzungudzira Soro./
> Vasikana ndee kumutari//
> Womira sezvitetyu mumu gwagwa/
> Wese vanomuda.///

The Smoking Gentleman, translated by Edgar Musarira
(Speaker: George Kahari)

> Look! See
> The smoking gentleman!/
> Click, he ignites
> The Peter Stuyvesant.[i]//

The smoke is seen
Wavering, trailing in the sky./
He smiles.
Ha! sweet! he says.//

Look, he shakes head./
The ladies stand stilled//
Like statues on the road./
All love him.///

Notes

These examples of black African speech are merely an introduction to the subject, which is vast. There are innumerable African languages and dialects in each of the many countries and regions of the African continent. Each has its own inflections and some sounds which are peculiar to it alone. However, because of an English-speaking audience's unfamiliarity with the subject, you may be able to use the speech of either example as the model for a character speaking some variety of black African English, whether it be Nigerian or Rhodesian, or any other. The quality of the dialect you hear on the CD is distinctly non-European and recognizably African, and so may serve in such a case.

The Shona dialect is widely spoken in East Africa. Practice the Shona poem on the CD simply by ear, playing it and saying it until you sound as nearly as possible like the original. Reproducing the speaker's vivid inflections and the un-English sounds of Shona may be a real challenge to your dialect-learning ability, but it will certainly strengthen your skill in matching any dialect by ear. Also, if you ever have to prepare for a role in which a character must speak phrases in his own native African dialect, deliberately incomprehensible to the audience, you may be able to substitute some of these. The meaning will be less important than the fact that you may sound believably African.

Plays

The Blood Knot	Athol Fugard	Zachariah
Boesman and Lena	Athol Fugard	Boesman, Lena, Old African
The Emperor Jones	Eugene O'Neill	Brutus Jones
The Gods Are Not to Blame[j]	Ola Rotimi	All characters
A Raisin in the Sun	Lorraine Hansberry	Asagai, the Nigerian boy friend

YIDDISH

YIDDISH NO. 1

Yente to Goldie[k] (Speaker: Alene Weissman)

Goldie, darling, I had to see you, because I have such news for you./

And not just every day of the VEEK news, VUNCE in a lifetime news.//

And VERE are your daughters? H'outside, no? Good./

Such diamonds! Such jewels! You'll see, Goldie, I'll find every VUN of them a husband.//

But you shouldn't be so picky./

Even the VORST husband, God forbid, is better than no husband, God forbid.//

And who should know better than me?/

Ever since my husband died, I've been a poor VIDOW, alone.//

Nobody to talk to, nothing to say to anyone, it's no life!/

All I do at night is think of him, and even thinking of him gives me no pleasure.///

Because you know, as VELL as I, he was not much of a person./

Never made a living,//

everything he touched turned to mud, *but better than nothing.*/

Aie! Children, children, they are your blessing in your old AYTCH.//

But my Aaron, may he rest in peace, couldn't give me children./

BELIEF me, he vos good as gold!//

Never raised his voice to me! But OTHERVICE, he VOS not much of a man./

So VOT good is it if he never raised his voice?//

VOT'S the use complaining?/

Other VIMMEN enjoy complaining, but not Yente.//

Not every VUMMAN in the world is a Yente./

VELL, I must prepare my poor Sabbath table, so good-bye, Goldie,//

and it VOS a pleasure talking our hearts out to each other.///

(margin glosses)

age

believe
otherwise

women
woman

YIDDISH NO. 2

To Ellis Island at Age Thirteen (Speaker: Louis Bloomberg)

You want me to hold the mike? (Yeah, just hold it.)/
Yeah? O.K., O.K., I'm gonna be an actor now. I take acting.//

(Acting?) RRIGHT. You ask me and I'll answer you./ *right*
(I just wanted to know the story of how you came here.)
Oh, I tell you, it VOSN'T so easy.//
I came here as a young fella, in the AYTCH thirteen,/
and I had trouble on my VAY.//
Mine, uh, uh, the company that I had a ticket come here, went bankruptcy,/
'n I was STUCKT on my VAY, in RROTTERDAM; this *stuck,*
was January.// *Rotterdam*
And it took 'bou' a week, till I went to try again, and
I came with a DIFFRRENT boat./ *different*
I'm supposed to come with the Amsterdam and I came with the Rindham.///

So that's the VAY I came here to ELLSE Island, that time—/ *Ellis*
to ELLSE Island, and, uh, the family, a small family, some-how they got mixed up WIT me.//
I'm supposed to come a week before,/
so I came a week later; VITCH they didn't know exactly
VEN I come;//
and they didn't come to take me down from ELLSE
Island./
So DEY took me; DESE people, what you call 'em? the
JEW'SH—uh—?//
(Jewish Agency.) They don't call themselves JEW'SH
Agency; what do they call them?/
Well, they took me down; I was there coupla days; they
feed you.//

Oy veh, it's one of the finest organizations!/
I forgot, I forgot the name! Maybe that's the biggest—//
for years and years—what's the name of them?/
Just this minute I forgot.//
They used to be on the East Side, and they
moved to Lafayette Street, 'n they moved now to a
DIFFRRENT PRACE—*'s the name of them?///* *different place*

YIDDISH NO. 3

Daughters and Sons (Speakers: Linda Cohn, Sue Weintraub)

Oh, mine Hannah, she's very sick./

They are putting needles in her arms, they are putting needles in her behind, they are putting needles in her legs,//

I've never—like a pin cushion. They don't know VOT to do!/

Well, tell me! Do you know, do they have any idea what it is?//

Of course they don't. VOT do the doctors know? Mine son is a doctor; your son is a doctor./

Oh, I have a son, let me tell you, what a doctor, you've never seen! He graduated from the Harvard Medical School.//

Really?/

But I hear you have a daughter that just got married?//

Oh, mine daughter, she had the loveliest VEDDING you ever saw in your life!/

Oh, how wonderful!//

Aie, my son-in-law, like you never saw!/

What does your son-in-law do?//

He's a lawyer, but that's all right. VITH VUN doctor in the family, VE don't need another; VE now need a lawyer:/

So, anyway, that's wonderful. Listen, are you coming with us to the trip to Israel, you know, that we're taking this summer?//

Oh, maybe I'll come if VE can get the money. I don't know—VE'LL see!///

Pronunciation Notes

The lilt of Yiddish is all important to the dialect. The sudden rise in pitch near the end of a sentence or phrase as in "H'outside, *no?*" "I forgot the *name* of them!" "A son-in-law like you *never* saw!" is an essential feature. Though in the italicized sentences you hear the characteristic lilt most clearly, it is present in every part of each example. Since it is related to Hebrew prayers, which are chanted, and Hebrew-language drills, which are shouted, keep it singing and strong as you practice, lifting the end of each sentence for emphasis.

As to sound changes, only consonants are listed below, and even these are not invariably changed, as is apparent in Nos. 1 and 2.

Consonant Changes

STANDARD	YIDDISH	
with	vith	*W* becomes v initially.
age	aytch	Soft *g* becomes *ch*.
believe	belief	Final *v* is sometimes *f*.
different	diffrrent	*Rr* is the respelling for a guttural *r*.
place	prace	*L* in a *pl* combination becomes indistinct, like *r*.

Idioms (Including Two Not Heard on the CD)

> Oy veh!
> My Aaron, may he rest in peace!
> What a doctor, you've never seen!
> A little meshugge (a little crazy)
> Schmoose (gossip)

Character Notes

Several types of Yiddish characters frequently met with in plays are apparent in the speech of the examples: the gossipy Jewish women of Nos. 1 and 3, and the aging immigrant of No. 2, a type of the Jewish elder who left the ghettos of Europe at an early age to start a new life in America, but who retains the rhythms and cadences and some of the constructions of his native speech.

Recordings

Everybody Gotta Be Someplace, Myron Cohen, laugh.com
My Son, The Greatest: The Best of Allan Sherman, Allan Sherman, Rhino/Warner

Plays

Dear Me, the Sky Is Falling	Leonard Spigelgass	Libby Hirsch
The Dybbuk	S. Ansky	All characters
Man in a Glass Booth	Robert Shaw	Mrs. Rosen, Mars. Levi, all other Jewish characters
The Old Jew	Murray Schisgal	The old Jew
The Price	Arthur Miller	Solomon
Street Scene	Elmer Rice	Abraham Kaplan

The World of Sholom Aleichem	Arnold Perl	Most characters

Musicals

Fiddler on the Roof	Joseph Stein, Jerry Block, Sheldon Harnick	Tevye, Goldie, Yente, Lazar Wolf, Rabbi, others
Funny Girl	Isobel Lennart, Jule Styne, Bob Merrill	Mrs. Brice, Fanny, others
The Zulu and the Zayda	Howard daSilva, Felix Leon, Harold Rome	Zayda, others

YANKEE

YANKEE NO. 1

Fred's Sons Do Their Duty[1]

thirty	*Fred Sawyer died back in THUHTTY-seven./*
	They had to dig 'im up last YEE-UH, to make way for the State Turnpike.//
	There's a LA-AW that says that some member of the family's
there	got to be THAYUH/
	when they lift 'im AOWT.//
	And so Fred's two sons, Paul and Sam,/
	drew lots to see which one would go.//
	Paul won, and when he came BAAACK that night, Sam asked 'im,/
	"D'you help th'm with the diggin'?"//
	"Yup."/
hard	"Was it HAAAD work?"//
	"Sure was!"/
	"Loam or SAAAND?"//
neither	"NEETHUH, clay."/
	"How wuz the box?"//
	"Not much left."/
	"D'you look IIN?"//
	"Yup."/
	"How was 'e?"//
poorly	"Kinda PO'LY."///

*Hetty Bliss Gets a New Axe*ᵐ

Old Hetty, she's quite a KAAAD. I went into town the other *card*
day and brought a double-bitted axe back home to 'er./
 KAAAVD H.B. right on the end of the handle.// *carved*
 By gorry, she was so happy that she was out chopping
wood with it before breakfast./
 You know, something a little mite fancy will tickle a woman
'most to death.///

YANKEE NO. 2

Chilly Weather (Speaker: Margo Skinner)

It snowed last night. UH-YEH!/ *yes*
'Bout time for a warm spell.//
Got a fire burnin' in the sittin' room. UH-YEH!/
Still though, I need to walk around in a SWEATUH.//
It is chilly! UH-YEH!///

YANKEE NO. 3

Captain Nickerson on *Good Cider and Old Records*ⁿ

I wanna get, I wanna get' drink this cider HEYUH— *here*
WHA'D you get this?/
 (Well) Aaaah! by God, that tastes good!//
 You get that in Jon'than Small's, did yuh?/
 (Yeh; he put an old dead fish in it so's to ripen it up.) *That*
ripened it up in good shape; I FIGGERED that's what t'was,
hain't had 'n done that in a good many YE-UH.// *year*
 (Takes one of those smoked herrings.) *By God, you take a*
smoked herring—boy! cats and mushrats and skunks'll come
for miles, see what you got.///
 Don't know about these specs HEYUH, what's, what's
this HEYUH?/
 (Some kind of bifocal.) By something, I can't see by it,
I know that.//
 WAALL, THEHUH, that's all right./ *well, there*
 Now, by God, I'm in business HEYUH,//
 and if I can get these shingle nails outa this box
HEYUH,/

"Anybody here seen Kelly?" Looks to me like that's been too close to that stove, kinda melted on the edges there, y' know, a little, see?//

(We'll put that here.) YEUH, "When I was Twenny-one," and that's "The Preacher."/

(Yeah?) "The Preacher!" (That's the one we just played, "The Preacher.") Oh, is it?//

(Yeah, looks like sun spots, y'don't know what 'tis.) I was tryin' to get these glasses fitted out HEYUH,/

across and you had 'em THEHUH with a line drawn ACROST 'em, like seein' round corners, HEYUH, 'n one thing 'n another!///

YANKEE NO. 4

She's a Rambler (Speakers: William Lyman, Stephen Klein)
(The spacing should be followed for each speaker separately.)

Well, Enoch!/
YUUH?/
How are you doin' today?//
Doin' all right. And yourself?//
Oh, pretty good,/
Good./
Wife's got a touch of the rheumatism, but she's doin' all
poor right, I guess, her PO' throat,//
Eh?//
car *What do you bet on the next KAAA comin' down the*
road *RO-OOD?*/
Eh, bet she's an even./
Bet she's an even? I'll bet she's an odd, I'll lay you five.//
Five what?//
Five—fifty cents./
All right. General Motors too!/
Rambler Y'know—no—I bet she's gonna be a RAMBLUH. Aaaaah!
HEYUH she comes!//
motor White MOTUH!//
HEYUH, she comes!/
UHYEH, HEYUH she—/
By God, she's an even!//
YEUH—but she's a RAMBLUH.//

Pronunciation Notes

Yankee dialect contrasts strongly with Yiddish, which precedes it on the CD. Its inflections are slow and deliberate, punctuated with pauses, as befits a laconic way of speech. Where Yiddish has changed consonants, Yankee has changed vowels; and sometimes the changes vary from one occasion to the next, even when used by the same speaker.

In the list below, the first two groups of vowel changes are presented with respellings, which you must associate with the pronunciations on the CD. The respelling *Aaa* for words like "back" is used to differentiate this short *a* from the one used in Southern, which is spelled *aa* in words like *naas* (nice), *Aa* (I). The Yankee short *a* is nearer the sound of *a* in "bat"; the Southern *a* is nearer the sound of *ah* in "bah"! The *ayeah* given below is so common in New Hampshire that it appeared on a witty license plate: "N.H. Live free or die. AYEAH."

Vowel Changes

STANDARD	YANKEE	
Yeah (yes)	Uhyeh or ayeah; sometimes yup	
here	heyuh	
there	thehuh	
year	ye-uh	
where	whar	
back	baaack	
sand	saaand	
card	kaaad	*Ar* to *aaa* is a consistent change.
carved	kaaavd	
sweater	sweatuh	
Rambler	Rambluh	
well	waall (occasional)	

Consonant Changes

STANDARD	YANKEE	
thirty	thuhtty	*R* silent, vowel sound *uh* like the sound of *a* in "sofa."
mother	mothuh	

Idioms

kinda po'ly
by gorry
a little mite fancy
'most to death
a warm spell
hain't done that
I figgered
mushrats (muskrats)

Character Notes

Rural types like the farmers of No. 4 and the housewife of No. 2 still abound in northern Vermont, New Hampshire and Maine. They are conservative, shrewd and knowledgeable in country ways. The Maine sea captain's salty speech is probably the most authentic of these examples, but also the most difficult to imitate because of its unself-conscious relaxed quality. Get its face-to-face directness along with its freedom. But keep your articulation firm like that in No. 1.

Plays

Ah, Wilderness	Eugene O'Neill	All characters
Desire Under the Elms	Eugene O'Neill	All characters
The Devil's Disciple	George Bernard Shaw	Anderson, the Dudgeon family, Essie, others
Ethan Frome	Owen and Donald Davis	All characters
Our Town	Thornton Wilder	All characters

CD TWO

FRENCH CANADIAN

FRENCH CANADIAN NO. 1

Real French° (Speakers: Joan Stuart, Peter Cullen)
(Je vais, tu vas, elle va—)
Eh, Wasp!
(Nous allons, vous allez, ils—)
Eh, buzz buzz! You got bad pain?/

It sounds like your mouth and your tum-tum is 'AVING a tête-a-tête.//

(What d'yah mean by that?)

Well, DOSE noi-SIZ you've been ma-KING for DE last 'ALF-ow-ER,/

it sound like a commercial for acid indiges-TION!//

(Very funny. Look, I'll have you know that these noises, as you call them, are French.)

DAT so, Pene-LOPE?

(Oh, you're so insulting! Just as I begin to take the trouble to learn your native tongue.)

Native tongue! Native tongue! If DAT'S my native tongue, babe, I must be a cross between a chic-KEN and a cocker span-YELL!//

(You know, I often wondered where you got your walk from.)

Listen, babe. I don't want to 'URT your fee-LING, but DAT'S not French.//

They'd lock you in the clinky as a Russian SPEE if you tried that back home—tried that back home in SH'KOOTS-MEE./

(You see? Here I am trying to do something about our national problem, and all—)

Hold DE phone, hold DE phone! You're not goin' to speak it DAT way, babe.//

It's like sex. You can't learn it out of a book. You got to go out DERE and pick it up for yourself.///

Toblé Tav'
(From "Mumsy and Dadsy Come to Dinner")

(I was referring to dinner. D'you have any plans?)

Oh well now, let me see./

DE French ambassador is ask me to try out the embassy's Coquilles St. Jacques;//

Monsieur Drapeau has indi-KATE that my pre-ZENSS would not go unnot-IST/

at a small soiree E's giving for four 'UNDRED guests//

at the St. Helene Champlain rest-TRONTUH;/

and Michelin 'AVE asked me to check whether I T'INK the Chateau Lyons is worthy of its fifth star.//

However, I T'INK it's more possible/

you can find me at Toblé Tav', 'AVING a hot DOIG.///

spy
Chicoutimi

FRENCH CANADIAN NO. 2

Winning the Stanley Cup in the Forum at Montreal
(Speaker: Bruce Gordon)

that's DAZZ a funny T'ING, there's about as many ways of
Canadian speaking French Canadi-ENN as there is French Canadi-
ENNS./
Quebec It's funny, you go to KAYBECK, and it's quite diff-RUNT
Chicoutimi from SH'KOOTS-MIH, or somewhere else.//
It's a funny T'ING, too, DAT it's very much like, if you
instance went to the British Isles, for in-STUNSS./
DEY have many ways of speaking; an Englishman or some-
one from Ameri-KAH or Cana-DAH, going over DERE//
would not understand at all what was being said by
English-MEN in Eng-LISH!///
DE hockey game is very important to all of us./
For in-STUNSS, I remember DE Stanley Cup game many
years ago,//
when it was an overTIME, and you know an overTIME
is sudden death!/
And if you get a shot and score DE goal!//
DERE'S DE champion-SHIP in your pock-ETT,/
and some money too.//
Richard ANYWAYS, I T'INK it was the great Maurice RISHARD
who finally put the puck in the net./
We were screaming "Score DE goal! Score DE goal!"//
And finally, with about two minutes left,/
he took a slap shot from the blue line, and Pow!—right
into the net.//
Two minutes in overtime, and it's all over./
DAT'S for sure, I'll never forget, that was the Stanley Cup!//
We took DAT home, and we kept it for T'REE years after
DAT./
DAT was some game.///

FRENCH CANADIAN NO. 3

Laurier on Liberty[p] (Speaker: Laurier LaPierre)

(On June twenty-six, eighteen seventy-seven, in one of the
most remarkable speeches of his career,/

Wilfrid Laurier attempted to curb the growing interference//

in the political life of the province of Quebec.)///

In our adversary's par-TIH, it is the custom to accuse us *party*
of irreligion. They reproach us with seeking to silence the administrative body of the Church,/

and to prevent it from TEACH-ING the PEO-PLE their DU-TIES as CITI-ZENS and EELEC-TERS.// *electors*

They reproach us with wanting to hinder the clergy from sharing in politics,/

and to relegate them to the sacristy.//

In DE name of what principle should the friends of Liberty/

seek to deny to the priest the right to take part in political affairs?///

In the name of what principle should the friends of Liberty seek to deny to the priest/

the right to have and to express political opinions?//

the right to approve or disapprove public men and their *acts*
ACKS?/

and to instruct the people in what he believes to be their duty?//

In the name of what principle should he not have the right to say that if I am elec-TID,/

religion will be indan-JERD,// *endangered*
when I 'AVE the right to say/
that if my ad-VER-sirree is elected, *adversary*
the state will be indan-JERD?//

No, let the priest speak and preach as he thinks BES';/ *best*
such is 'IS right; and no Canadian Liberal will dispute that right.///

Pronunciation and Character Notes

French-Canadian English is vivid, highly variable and intensely interesting, with strong social and political overtones, as apparent in these examples. They are clear enough to guide you in choosing which example to use as a prototype for a particular role. The first speaker is a vigorous delightful Quebecois type, his origins habitant, his brand of comedy slyly anti-English Canadian. The second speaker is more relaxed, dedicated less to politics than to hockey, which is practically a religion in Quebec. The third speaker's slight accent does not detract from the impression he gives of cultivated urbanity and political wisdom and savoir-faire.

This dialect is easy to learn. Its changes, listed below, are few. Its characteristic qualities are energy and clarity of articulation, even in its dialectal features. The chief change is that the stressed syllable is not the expected one, but the one that would be used if the corresponding French word were spoken. These emphatic blows on unusual syllables punctuate the sentences like exclamation points. Learn the particular words heard here, and apply the principle to similar words you may need to use in a speech or improvisation.

The respelling in these examples uses capitalized letters for the syllable with the unexpected stress, not for the entire word: elec-TID. It uses hyphens to divide capitalized words that are not restressed, but separated into two equal stresses; DU-TIES, TEACH-ING.

The most curious sound change in French Canadian is that heard in the pronunciation of the place name Chicoutimi as *Shkootsmee*. This addition of *s* to a middle *t* or *d* is heard in other words, particularly in casual French Canadian: *cardz-nahl* (cardinal); *partsee* (party).

Vowel Changes

STANDARD	FRENCH CANADIAN	
spy	spee	Long *i* becomes *ee*; only occasionally.

Consonant Changes

STANDARD	FRENCH CANADIAN	
have	'ave	Initial *h* is frequently dropped.
think	t'ink	Initial *th* becomes *t*.
Chicoutimi	Shkootsmee	See note above.

Plays

The first three plays on the list are English-language plays that include characters who speak with a French-Canadian accent. In the case of *The Happy Time*, either French or French-Canadian accent may be used, as the play is about a French family that moved to Canada. *Riel* deals with the hero of the Red River Rebellion of 1869–70 and 1885–86. Riel, Xavier, François and other characters belong to the Métis, the French-Indian half-breed group that first settled the Canadian Northwest. Though the Métis dialect is distinctly Indian-influenced in intonation and pronunciation, an authentic source may not be obtainable, and the use of French-Canadian English would help to establish the Métis' separate Quebec-related identity.

The remainder of the plays were originally written in Quebecois French, which is the French of Quebec as distinct from the French of Paris. They were written in Joual, which is one of the speech modes of the Quebec working class, both rural and urban. Joual includes both archaic expressions and Anglicisms that are contemptuously called "franglais" by some of the educated of Quebec. However, Tremblay uses it with pride and flair as the speech of the people, and his translators have retained this special quality. The use of the French-Canadian accent for the French Canadian characters, while not essential in some cases, would certainly be appropriate.

Charbonneau et le Bon Chef	John T. MacDonough	All characters
The Happy Time	Samuel Taylor	Most characters
Riel	John Coulter	Riel,[q] other Métis, André, Quebec mob
Bousille and the Just	Gratien Gélinas	All characters
Hosanna	Michel Tremblay	Both characters
Les Belles Soeurs	Michel Tremblay	All characters
Like Death Warmed Over	Michel Tremblay	Hélène, others
Tit Coq	Gratien Gélinas	All except Rosie and the Commanding Officer
Yesterday the Children Were Dancing	Gratien Gélinas	All except Louise and O'Brien

ENDNOTES

[a] Nasalized.
[b] *Pachucos*, street toughs.
[c] The literal translation is: Clear accounts and thick chocolate.
[d] From *Americans Speaking*, National Council of Teachers of English records.
[e] From The Sit-in Story, Folkways Records, 5502.
[f] Boston University
[g] This line is omitted from the spaced repetition.
[h] From the record *Rhodesian Poets*. Berry Trust Co., Salisbury, Rhodesia.
[i] A Peter Stuyvesant is an expensive cigar.
[j] This play (published by the Oxford University Press, London, 1971) is an interpretation of the Oedipus situation in Nigerian tribal terms. It won first prize in the African Arts/Arts d'Afrique playwriting contest in 1969.
[k] From the libretto of *Fiddler on the Roof* by Joseph Stein.

[l] From *More Bert and I*, Bert and I Records, Ipswich, Massachusetts.

[m] From *More Bert and I*, Bert and I Records, Ipswich, Massachusetts.

[n] From *Cape Codder and Down Easter*, Droll Yankees Records, D.Y. 7.

[o] *Real French and Toblé Tav'* from L'Anglaise, Funny You Should Say That, RCA LSP 4352, CBC LM 72.

[p] From *The Most Celebrated Speeches of Sir Wilfrid Laurier*, RCA Victor CC 1025

[q] Riel, educated in Montreal, may use either educated or colloquial French Canadian.

5

STANDARD ENGLISH:
NORTH AMERICAN AND BRITISH

In the texts of the North American and British examples which follow, no respellings are used for vowels and consonants regularly and typically different, such as *a* in "can't" or in "all"; *o* in "lot" or in "coffee"; *t* as in "little"; *r* before a consonant, which is silent in British speech but heard in most North American. This procedure is followed with the British dialect group, as it is with the North American.

The contrasting North American and British pronunciations of these sounds are illustrated and emphasized in the paired sentences, one in either standard form, which follow the last North American example. Notes closely comparing the varying usages follow. They are given there as they relate equally to both the standard forms.

STANDARD NORTH AMERICAN
STANDARD NORTH AMERICAN NO. 1

From the poem *Tower Beyond Tragedy* by Robinson Jeffers (Speaker: Marian Seldes)

...they have not made words for it;/ to go behind things,//
beyond hours and ages,/
 and be all things, in all time,//
 In their returns and passages,/ in the motionless and timeless
center,//
 in the white of the fire.///

...How can I express the excellence I have found,/ that has no color but clearness;//

No honey but ecstasy;/ nothing wrought nor remembered;// no undertone nor silver second murmur
That rings in love's voice,/ I and my loved are one;//
no desire but fulfilled; no passion but peace,/
The pure flame and the white,// fierier than any passion;/
no time but spheral eternity://...
...I have fallen in love outward.///

STANDARD NORTH AMERICAN NO. 2

The First Man in Space[a] (Speaker: Howard K. Smith)

We had, after all, anticipated so long this country's first effort to place a man in orbit;/
we had encountered so many maddening delays,//
we had feared, each of us, for the safety of the chosen astronaut, John Glenn;/
this despite the knowledgeable assurances of the officials most intimately connected with the project, and of Colonel Glenn himself.//
We had, on a memorable day in January, moved to within twenty minutes of launching time,/
only to see the vast effort defeated again by weather;//
and finally we reached today, February twentieth.///
We had by this time, it seems to me, reached something bordering on hypnosis,/
irresistibly drawn to the event, and at the same time repelled by our fears of what might happen.//
We think, I think, some of us tried to spare ourselves/
from living those crucial moments by tending to believe,//
even when the launching was only a few minutes away, that/
something would happen and the flight would again be postponed.//
But then, inexorably, it seemed, the elaborate ritual continued,/
and the clock gnawed away at the remaining moments of delusion that we had permitted ourselves.//
The launch occurred!/
It was both frightening and beautiful.//

And then for almost five hours/
few people in the civilized world allowed their thoughts
to stray very far from the American in space.//...
It was at the end of those five hours,/
when word was flashed that Colonel Glenn had landed
safely, at the end of three orbits,//
and had been brought, hale and hearty, aboard a ship in
the A'lantic,/
then, that the great sigh arose.///

STANDARD NORTH AMERICAN NO. 3

Directing Can Be an Education (Speaker: Muriel Dolan)

You know, directing shows can be an education in itself./
Thinking about some of the more recent things I've
done.//
A year or so ago, The Lady's Not for Burning./
I was so in love with that language,//
so beautiful!/
And, and such a fantastic amount of brilliant dialogue,//
that I was overwhelmed by it, and didn't see the problems/
for the audience.//
One of the comments that we got afterwards/
was the fact that people had a very, very hard time follow-
ing the language.///
'N then Albee's Tiny Alice, which is as different from/
Fry's Lady's Not for Burning, as anything could be://
I was really scared when I started that one!/
'Cause I wasn't always sure just what it did mean;//
and neither were a lot of other people./
But everyone did seem to get something from it just the
same.//
It was theatrical; it was exciting;/
it had a certain kind of unity of its own;//
and yet I could argue with people from now till doomsday
about exactly what it meant./
And this is strange to me//
because I don't know how something can be successful if
you don't clearly understand what it is./
But that's the way it was.///

STANDARD NORTH AMERICAN NO. 4

On Canadian Theatre (Speaker: Mavor Moore)

The nineteen fifty-seven edition of the Oxford Companion to the Theatre says/
Canada, a young country, has a young theatre,//
which cannot as yet claim professional status,/
yet it is probably no more amateur than were the first plays of medieval Europe.//
Well, in an attempt to explain our precipitous emergence from these dark ages,/
the Companion has a supplement,//
which notes that a professional theatre has now come into being in Canada with the opening in nineteen fifty-two/
of the Shakespeare Playhouse at Stratford, Ontario.///
But the Companion's estimate does reflect, I think, the success with which Canadians have presented to the world over the same period/
a singularly blank face.//
When they went abroad, of course, either as performers or playwrights,/
Canadians had few obvious distinguishing marks to take with them.//
When Mack Sennett and the Warner Brothers and Louis B. Mayer,/
Mary Pickford, Marie Dressier, all took off for Hollywood,//
they became ever after known as Americans;/
so did Maude Adams, Margaret Anglin, Walter Huston, in the theatre.//
Bea Lillie left Toronto to become, as far as the public was concerned, an English performer./
And even in our own time, Lorne Green, most Americans think, is American;/ Christopher Plummer, most of the English think, is English.//
To seek a pattern in our past and present isn't easy;/
to identify the stubborn native streak, but it's there!//
One thing that becomes clear is that satire has always been our strongest vein./
Satire has all along been our most effective form of self-defense//

against the very British and American culture we've borrowed and were sometimes swamped by./

We know our neighbors better than each does the other./

The job now is for our playwrights to turn that satire on ourselves.///

PAIRED SENTENCES, STANDARD NORTH AMERICAN AND BRITISH

Associate the respellings with the exact sounds you hear on the CD. Work by sound more than by sight. In each case, the first example is North American, the second British.

Group 1
(Speakers: Bob Osolinski, New Jersey, Boston; Rowena Stamp, South Africa, England)

What kept Dawrthy so long? She was washing the coffee paht.
What kept Dorrothy sayo long? She was washing the coffee pot.

I've gaht a lahdduh change in my pahket.
I've got a lot of change in my pockitt.

Whad I want is a noo watch.
What I want is a nyoo watch.

When Jahn had gahn, the sun shohn.
When Jon had gone, the sun shone.[b]

He figgered he would be at the tahpa the list.
He figyerd he would be at the top uv the list.

Group 2
(Speakers: David Alkire, California; Evangeline Machlin, England, Canada, United States)

Get that daug out of the bahx office; they'll hear his barks in the theader.
Get that dog out of the box office; they'll hear his bahks in the theatuh.

I've lost my stahp watch; it's naat in my paaket and I don't know where to look for it.

I've lost my stop watch; it's not in my pockitt and I don't know hwere to look forrit.

He likes fawrin food, haht curree and chahp suey, but he can't use chahpsticks.

He likes forrin food, hot cuhrree and chop suey, but he cahn't use chopsticks.

Most styoodents think the use of modern nooclear weapons is imawrl.

Most styoodents think the use of modern nyooclear weapons is immorral.

You can buy this cahntact cement in very smoll bahddles at very large cahst.

You can buy this contact cement in very smawll bottles at verry lahge cost.

Notes for American and Canadian Actors[c]

1. The short vowel *o*:

bahx	box
mawrl	moral

The respellings left above show the sounds you normally hear in your head for "box" and "moral." The spellings on the right here represent the short *British* o, not the American. Round your lips a little to get the British vowel as in most of the short *o* words in the sentences above. But *unround* the sound you use in "moral," again producing the British short *o*. This may be the vowel you use in "watch," but not necessarily. You may be saying *wahtch*. If you are from New York, your "coffee" may be *cawfee*, your "off," *awff*. Use the British vowel here too.

2. The vowel *a* as in *all*:

small	smawll

For "small," use the vowel you may now use in "moral." Round your lips to get it. Listen to "small" in the last of the last pair of illustrative sentences in the group preceding these "Notes." Reproduce it exactly.

If you are Southern, reverse the change. You may be saying *ohlways*. Relax your present lip rounding in these words very slightly to *aw*.

If you are from New England, you probably are already using the British short *o*, or something close to it, in all these words and will have no trouble. However, watch "short!" Don't call it *shot*; call it *shawt*.

This is a tricky change as North American standard speech admits pronunciations using various degrees of roundness for the vowel *a* followed by *ll*.

3. The vowel *a* as in *can't*:

can't cahn't

Change most of the words rhyming with those in the list below to the broad *ah* used in British speech. A few exceptions are noted. Consult your dictionary when in doubt.

dance	dahnce	(but lance, not lahnce)
path	pahth	(but hath, not hahth)
laugh	lahff	
after	ahftuh	
grass	grahss	(but lass, not lahss)
ask	ahsk	
past	pahst	
grasp	grahsp	(but asp, not ahsp)

4. The consonant *r* before another consonant and in final *er* syllables:

large lahdge
larger lahdguh

Drop *r* before consonants. Keep your tongue low in your mouth to stop the *r* from sounding. Drop *r* also in final *er, or* and similar syllables. But do not say *ah*. Say *uh*.

5. The consonant *t* in a middle position:

twenny bahddles twenty bottles

Pronounce *t* crisply. Make it sound like the *t* of "not" when emphasizing that word. The middle *t* many Americans use is very nearly a *d*. If *t* comes next to *n* or *l*, they often drop the *t*. Notice *A'lantic* above in Example No. 2. Restore the *t* after *n*, especially in phrases like "want to do it", "got to go." Keep them fast, but sharp.

6. Respelling the transcriptions of standard British English:

In playing and saying the British examples, write in respellings of your own, if needed, to alert you to the changes you must make, as suggested above. There are certainly other changes, but these will be enough, if you take care to use the light, deft quality of articulation you hear and the constant up-and-down inflection patterns. If you can match these two aspects of British speech, slips in pronunciation will not matter.

7. Types of standard British:

The variety of styles below is important. Englishmen do not agree on what is correct! Example No. 3 is Establishment speech. The speaker was from a private school in South Africa more English than some upper-class English in its pronunciation. Her *so* in the last sentence approaches *sayo*. *Ayo* for long *o*, especially in *oh, no* and *so,* is still a typical "received" pronunciation of long *o*, but is no longer present in average educated British speech, as No. 2 shows. No. 4 gives the speech of the British-trained actor, but did you notice that the Horatio who answers him is American, and that there is little significant difference between his speech and Hamlet's? When Canadian and American and British actors appear on the same stage, they may not be asked to use an identical pronunciation, but merely to modify sharp differences and to maintain

clarity. The speech of the late Margaret Webster, actress and director, in No. 1, is as fine an instance as you may hear of the best of British cultivated speech, modified by much work and residence in North America. It is warm, resonant, expressive, beautifully modulated, every syllable readily understood because of its firmness and fullness. You should try to achieve these qualities. Notice how they are also present in the first example of North American standard speech, spoken by Marian Seldes, an American actress. Thus they are fully appropriate for the American or the Canadian stage.

Notes for British Actors[d]

1. The short vowel *o*:

box	bahx
moral	mawrl

Follow the paired sentences in changing your short *o* to *ah*. In the case of "moral," "foreign" and similar words, it must change to *aw*. Native New Yorkers call "coffee," *caw-fee*, as noted above.

Notice also the elision of *r* in "moral"; this usually occurs in "foreign" also.

A sentence like "This foreign movie is not at all immoral" may be *This forn movie is naht at oll immawrl.*

2. The vowel *a* in *can't*:

cahn't	can't

Change your broad *a* to short *a* in all the words listed previously in Note 3 under "Notes for American and Canadian Actors."

3. The consonant *r* before another consonant, and in final *er* syllables:

lahdge	large
lahdguh	larger

Restore the *r* to these syllables. Overdo it, if necessary, lengthening and strengthening it. Respell it as double *r* in the text

of the example you are playing and saying, to alert you to it each time it occurs.

4. The consonant *t* in a middle position:

twenty	twenny
bottles	bahddles

Reduce or drop *t* after *n* in the middle of a word. Soften your *t* to a modified *d* in words like "bottle," "little," "city." It is as brief a sound as the *t* you use; do not lengthen it; keep it light and unobtrusive.

Watch for the elision of the syllable *ted* to simply a *d* in a past-tense verb. "I wanted to come" is usually *I wann'd t'come.* "I decided to do it," "I started to go" become *I decide' t'do it, I starred t'come.*

5. Respelling the transcriptions of North American standard English:

In playing and saying the North American examples, write in respellings of your own, if needed, to alert you to the changes you must make. For instance, you might write in *balm* for the word "bomb." You might cross out all *r*'s before consonants, and emphasize medial *t*'s with capitals: *liTTle.* Match the inflection patterns; they are subtly different in educated American speech.

6. Types of standard North American:

Nos. 1 and 4, spoken by Marian Seldes of New York and by Professor Mavor Moore of Toronto, are excellent models for professional character roles or for classical roles. Both have clear articulation and impeccable pronunciation. The speech of No. 3 is colloquial, direct and vigorous. It is appropriate for straight roles. No. 2 gives you the speech of a national news broadcaster, trained to communicate to all types of hearers. For less sophisticated speech, refer to the note on p. 28. Adopt the relaxed style of Midwestern speech with less of the regional drawl, and your Canadian or American accent will be believable.

STANDARD BRITISH

STANDARD BRITISH NO. 1

The Brontë Sisters (Speaker: Margaret Webster)

I accompanied her in her walks on the sweeping moors./
Oh, those high, wild, desolate moors!//
Up above the whole world, on the very realm of silence!/
Miss Brontë said, "My sister Emily loved the moors.//
Flowers brighter than the rose bloomed in the blackest of the
heath for her./
Out of a sullen hollow in the hillside,//
her mind could make an Eden./
She found in the bleak solitude many and dear delights,//
and not the least, and best loved, was liberty."///

STANDARD BRITISH NO. 2

Home with an American Degree (Speaker: Patrick Tucker)

Well, I suppose I am leaving America with one or two
tangibles./
I have, uh, a pair of glasses, a beard and a master's degree//
very nicely printed in Latin and kindly bound in plastic,/
which sums up quite a bit of the university curriculum and
attitudes over here.//
I came knowing no one;/
knowing nothing about the educational system.//
I go back knowing a lot of people,/
and having got very close with quite a few of them;//
and also knowing a great deal about the American system./
It doesn't always come out so well, compared with the
English system as far as educational goals are concerned.//
But certainly as far as a broad education,/
as far as, uh, quite a balanced program; it is very good.//
I did find what I was looking for, which was a—/
uh—a searching towards knowing,//
given an opportunity to failing, an opportunity to find out,/
which was very satisfactory.//
I came thinking about going into theatre./
I leave knowing I'll be going into theatre, one way or the
other.///

STANDARD BRITISH NO. 3

On Safari in Africa (Speaker: Rowena Stamp)

From the time that I was very little, we went on safaris, my mother called them,/
up into Africa, and we went up to Dar Es Salaam, and Uganda.//
And we—we used to pack our car up, my sisters and my mother and I, and would,/
it was an old American Plymouth, 1953 or something.//
And we'd pack it up with all of our gear, and we'd go trundling off to the Game Reserve,/
leaving early in the morning; you'd—you'd stay in the camp during the, you know, during the night;//
and it was an enclosed area with a barbed wire fence around it so the animals couldn't get in,/
with what we called rondavels^e all around,//
which were tiny little huts that looked like African huts; they were designed after them./
And we'd leave at four o'clock in the morning to go out and see the animals, when they were first going down to the water holes.//
And the advantage about this is, nobody else was up at that hour, and/
the animals weren't scared away;//
and they were all very intent on getting down to the water hole and bathing;/
the elephants would go down and splash themselves with water.//
We used to go up into these towers that would be right by the, by the water holes;/
and you could climb up and you could see for miles and miles around; it was so beautiful!////

STANDARD BRITISH NO. 4

From Shakespeare's *Hamlet*, Act III, Scene II
(Speakers: Jeremy Dix-Hart, Robert Reznikoff)

What ho, Horatio!?
(Here, sweet lord, at your service.)
Horatio, thou art e'en as just a man

As e'er my conversation cop'd withal.//
(O! my lord,—)
Nay, do not think I flatter;
For what advancement may I hope from thee,/
That no revenue hast but thy good spirits
To feed and clothe thee?//...
 Give me that man
That is not passion's slave, and I will wear him
In my heart's core,/
 ay, in my heart of heart,
As I do thee.//
 Something too much of this.///
There is a play tonight before the king./
One scene of it comes near the circumstance
Which I have told thee of my father's death.//
I pr'ythee, when thou seest that act afoot,/
Even with the very comment of thy soul
Observe mine uncle;//
 if his occulted guilt
Do not itself unkennel in one speech,/
It is a damned ghost that we have seen,
And my imaginations are as foul
As Vulcan's stithy.//
 Give him heedful note,
For I mine eyes will rivet to his face,
And after we will both our judgments join
In censure of his seeming.///

Plays in Which British and North American English May Be Contrasted

	BRITISH	NORTH AMERICAN
I Am a Camera		
John Van Druten	Christopher Isherwood, Sally Bowles, Mrs. Watson-Courtneidge	Clive Mortimer

The Love of Four Colonels

| Peter Ustinov | Desmond de S. Rinder-Sparrow | Wesley Breitenspeigel |

The Odd Couple

| Neil Simon | Gwendoline, Cicely | Oscar Madison, Felix Ungar |

The Apple Cart

| George Bernard Shaw | Most characters | Vanhattan |

ENDNOTES

[a] From an ABC broadcast, February 20, 1961.

[b] American and Canadian actors note: The short British *o* is not respellable.

[c] The left-handed lists represent your standard pronunciations. Change to those on the right.

[d] The left-hand lists represent your standard pronunciations. Change to those on the right.

[e] An Africanas word. The rondavel is a replica of the universal African hut, made with corrugated iron and brick instead of poles, mud and thatch.

6
DIALECTS OF GREAT BRITAIN AND IRELAND

COCKNEY[a]

COCKNEY NO. 1

From *Major Barbara* by George Bernard Shaw[b]
(Rummy and Snobby, as heard on the CD)

Feel better ARTER your meal, sir?/	*after*
Eh? NAAOH.//	*no*
Call that a meal? Huh! Good enough for you, PRAPS;/	*perhaps*
but wo' is it to me, an intelligent WORKIN' man?//	
WORKIN' man! He he! WOT are YUH?/	
PYNTUH.	*painter*
YUS, I DESSYE.//	*daresay*
AAOH YUS, you DESSYE! I know!/	
Every loafer that can't do NOTHINK calls 'ISSELF a	*himself*
PYNTUH.//	
Well, I'm a real PYNTUH. GRYNUH. FINISHUH!/	*grainer, finisher*
Thirty-eight bob a week when I can get it.//	
Then why don't you go and get it?///	
I'll tell you why./	
FUST, I'm intelligent—fff! it's rotten cold here, brrr!//	
YEUH, intelligent beyond the STYTION o' life into which	*station*
it 'AS pleased the CAPT'LISTS to call me;/	
and they don't LAAK a man that sees FROO 'em.//	*like, through*

85

Second, an intelligent BEIN' needs a DOO share of 'APPINESS/

so SAAOH, *I drinks something cruel when I gets the chance.//*

Third, I stand by me class,/

half *and do as LI-ULL as I can so's to leave ARF the job for me fellow-workers.// ...*

name WOTS your NYME?/

Rummy Mitchens, sir.//

Well, your 'ELTH, Miss Mitchens./

Missis Mitchens.//

WO'? AAOH, Rummy, Rummy!/

Respectable married woman, Rummy, GITTIN' rescued by the Salvation Army by PRETENDIN' to be a bad un. Yes,

same, game the SYME old GYME.//

WOT am I to do? I can't starve./

Them Salvation lasses is dear good girls,//

but the better you are, the worse they likes to think you were before they rescued you./

Why shouldn't they 'AVE a bit of credit, poor loves?//

They're worn to rags by their work./

And where would they get the money to rescue us//

if we was to let on we're no worse than other people?/

ladies You know what LYDIES and gentlemen are!//

THIEVIN' swine!////

COCKNEY NO. 2

From *Home* by David Storey
(Speakers: Robin Bartlett, Judith Robinson)

comes Me dentist CUUMS from Pakistan./

Yours?//

Took out all me teeth./

Those not yours, then?//

All went rotten when I 'AD my little girl./

There she is, waitress by the seaside.//

stuck *And you STUUCK 'ERE./*

Don't appreciate it.//

They don't./

NEV-UH!////

Might take this down if it doesn't rain./

Cor blimey ... Take these off if I thought I could get 'em on again;//

tried catching a serious disease./

When was that, then?//

Only 'AD me in two DYES. Said, "Nothing the matter with you, my girl."/ *days*

Don't believe you.//

Next thing—got 'OME; smashed everything in sight./

NAAOH!//

WINDUHS. Cooker ... Nearly broke me back./

Thought I'd save the telly.//

Still owed eighteen MUUNTHS. Thought, everything or nothing, girl.///

COCKNEY NO. 3

Sore Feet (Speakers: Robin Bartlett, Judith Robinson)

Cor blimey!/

WOT'S the matter with you, Maggie?//

Oh, me feet are killin' me! Been walkin' on them, all day in the RYNE./ *rain*

Why's that?//

I don't know, I think I've got arthritis./

In your toes, 'AVE you?//

I think I've got it in my big toe, anyHAAOW!/

Bloody terrible, I tell you.//

Feel like cuttin' it off./

Cut off your toe?//

Well, I don't know, I can't go through this agony any more!/

Never!//

I know—it just hurts and hurts and hurts!/

Been to a doctor?//

Went to a doctor, but he said I was just COMPLYNIN'
for no reason at all!/

Kind of doctor's that? Don't believe you.//

BLEEDIN' 'YPOCRITE, I think./

Let me TYKE a look at it.//

Oh it'll be all right if I talk about SOMETHIN' else./

Maggie, it's all blue!//

I know it's all blue!///

Pronunciation Notes

The speakers in No. 1, from a recording of an important production of the play *Major Barbara*, speak as useful an example of recorded stage Cockney as is known to the author. It is authentic, but completely understandable to the American or Canadian ear. Its inflections, with the sharp slides in pitch of *Naaoh! Saaoh*, its biting articulation, with the exploding *g*'s and *t*'s of "Why don't you go and get it? I'll tell you why!," its speed, punctuated with emphatic pauses, make it easy to pick up as you play and say it.

Example No. 2 is Liverpool Cockney, as was used in the stage production of the play from which it comes, David Storey's *Home*. Here there is a vowel change not heard in London Cockney, but belonging to the North, and heard again in the North British examples—the short *u* of "come" changes to the vowel in "could," respelled *uu, cuum*.

Vowel Changes

STANDARD	COCKNEY	
painter	pyntuh	The *ay* becomes long *i*. This is the most important vowel change. (*Er* is *uh*, as in all standard British English.)
no	naaoh	In exclamations.
like	laak	Long *i* becomes *aa*. (Compare North American Southern.) This is an occasional change in Cockney.

Consonant Changes

STANDARD	COCKNEY	
have	'ave	Initial *h* dropped. Most characteristic.
after	arter	After *ah*, *ft* becomes *rt*; *f*, *rf*. Also very
half	'arf	characteristic.
STANDARD	COCKNEY	
little	li-ull	Middle or final *t* dropped; a jerk substituted.
what	wo'	
through	froo	*Th* becomes *f*, initially and finally, as in *worf*, not heard here.
worth	worf	
working	workin'	*Ing* regularly becomes *in'*.

Character Notes

The aggressive, resilient quality of the Cockney is his essential characteristic. There must be assertiveness, independence, slyness and humor in the inflections as well as in the words. Those that you hear in No. 1 and to a lesser degree in No. 2 should dominate your Cockney. The type is suggested by the text in almost every play that includes a Cockney, and there are many.

Example No. 3 is an improvisation in Cockney. The actresses who spoke the dialogue of Marjorie and Kathleen in Example No. 2 simply continued on their own, retaining the characters and the situation as they improvised. This is a useful way to begin improvising. One dialectal error is apparent—"It hurts and hurts and hurts!" This, of course, should have been "It 'urts and 'urts and 'urts!" However, such lapses often happen in improvisations. They are not serious as long as the over-all quality of Cockney—inflections, rhythm and tempo, as well as pronunciation changes—is present.

Plays

The Corn Is Green	Emlyn Williams	Mrs. Watt, Bessie Watt
The Emperor Jones	Eugene O'Neill	Henry Smithers
Home	David Storey	Marjorie, Kathleen
Major Barbara	George Bernard Shaw	Rummy, Snobby Price, Bill, Shirley
Outward Bound	Sutton Vane	Mrs. Midget
Pygmalion	George Bernard Shaw	Eliza, Mr. Doolittle
Saved	Edward Bond	All characters

Musical

My Fair Lady	Alan Jay Lerner and Frederick Loewe	Eliza, Mr. Doolittle, Chorus

WELSH

WELSH NO. 1 (SOUTH WALES)

Johnny Goes to Choir Practice (Speaker: Patrick Tucker)

Well, ye see, Johnny came 'OME with his black hat on,/ and he sat down and he said, *"Where's me COET?"//* *coat*

bach^c

So, Mum, she comes out and she says, "Oh, what d'you want here, boy BACCH?"/

He says, "I want me COET, I got to go out to church, to CHAP-EL, ye see, I gotta sing for the CHO-IR.//

And, anyway, Vicar is coming down to speak to us this ev'nin'."/

"Well," she asked me, "What's he goin' to speak about?"//

"We're speakin' about EV-IL, ye see,/
and what we're all doin' about it."//

don't know

"I DOEN'T KNOE about that—I mean, there's no evil 'ere, is there?/

Just common FOEK sittin' round the TAB-LE!"//

So anyway, Vicar comes down, and he says, "We're all goin' to 'ELL!"/

"What's that about? I mean!"///

WELSH NO. 2 (NORTH WALES)

A Farmer Loves the Welsh Countryside
(Speaker: An unidentified Welsh farmer)

Oh, thank God, thank God for it!/
I'm going down now to cut peat in May, down on the bog.//
Oh dear dear, I enjoy that!/

pheasants

the BRAC-ING air, the PEZ-ANTS PASS-ING,//
wild duck COM-ING, snipe GO-ING about me, hares VUND-ING,^d/

gum

by GUUM, I am at home there! EX-ACT-LY!//
Oh, we are NEIGH-BORRR-LY, oh yes! the old GEN-ER-ATION.///

Oh yes! and the thing I like, I can go over on my neighbor's land, you know!/

I can hunt with five packs, yet, in this ICE-O-LATED place, you know!//

I used to ride, but now I go with somebody else, in their car,/

Everybody being SO-SHAB-ULL and HAP-PY!//

When I was young, I'd shoot at everything, I think!/

Oh, not now! Oh yes!//

I'm getting more fond of keeping their COM-PANY now.///

WELSH NO. 3 (NORTH WALES)

Jones the Knife, and Jones the Butcher
(Speaker: George Imrie)

But you know, when I was a little boy, I had some very good friends,/
and amongst them was one called Clifford Jones.//
And now, Clifford Jones, he was one of the greatest surgeons that EFFER left the North of Wales. And he went to England./ *ever*
And when he went and STAR-TED as a surgeon, he was known as Jones the Knife.//
And we had another LIT-TLE TI-NY man there. He was called Emlyn Jones./
And when I was a boy, he cut our meat for us; and he was just known as Jones the Butcher.//
And when I was a boy, if you asked him as a special priv'lege,/
he would GIFF you one shilling and sixpence for a rabbit,//
as long as she was nice and clean,
and she was not full of BA-BIES.//
But Mr. Jones, after the war of 1939 and 1945 was over,/
he passed over the Great Divide.//
He was a very HAP-PY man;/
and he went to chapel, EFFRY Sunday at least once;//
and he had a great singing voice;/
and he made a great deal of happiness for a lot of people.///
But he could cut up a leg of lamb like no one I have EFFER known in all my days./
And many, many a time I would sit and talk to him.//
And I would try and sell him my rabbits,/
because that was how I made my money when I was a little boy.//
He gave me all my pocket money,/
and he sold my rabbits to the English tourists when they came down there;//
'cause they didn't know any BET-TER that these rabbits weren't worth eating./
But they were BET-TER than nothing, and they were BET-TER than beans on TO-OST!// *toast*
And when he and I did this, sometimes when I was only about SIX-TEEN,/

> He would take me down to the pub and he would sneak
> me a pint of BEE-ER.//
> And after one or two beers both he and I would get to be
> feeling a great deal BET-TER./
> And he made me a very very happy young boy.///

Pronunciation Notes

The extraordinary singing inflections of Welsh can best be matched
if you almost sing the examples with the speaker. This is a delightful
exercise with No. 2.

Think of the inflection pattern as a melody to learn. Carry your
voice up and down with the speaker, through his pitch leaps and slides
of a full octave. Notice the staccato, almost syncopated division of
syllables in all three examples, often with a sharp rise of pitch in the
second syllable: CHO-IR, NEIGH-BORRR-LY, HAP-PY! It can happen
in a one-syllable word: BEE-ER, TO-OST! Where no change of pro-
nunciation is involved, the words are spelled normally, but in capitals
and hyphenated, to emphasize this unique feature of Welsh dialect.

The use of italics in all the examples of Welsh is merely to bring
your attention closely to especially good instances of the pitch patterns.
But they are so prevalent that the entire text of each might well have
been italicized.

Vowel sound changes are subtle but slight. The only one respelled
is the diphthong in "coat" as *coet*. Consonant changes are few, but
important; "just" to *chust* (not heard on the CD), "ever" to *effer*.
A strong Welsh dialect might unvoice several consonants: "very good,"
ferry goot. *S* is often sustained: "isolated" is respelled *ice-o-lated* to
suggest this. The guttural *ch* in *bach*, the German *ch*, respelled *bacch*,
occurs also in Scottish and Irish dialect examples.

Vowel Changes

STANDARD	WELSH
coat	coet

Consonant Changes

STANDARD	WELSH	
ever	effer	*V* is unvoiced and becomes *f*.
just	chust	*J* is unvoiced and becomes *ch*.
bach	bacch	*Ch* in a final position following a vowel is pronounced like the guttural German *ch*.

STANDARD	WELSH	
ing	in'	*Ing* becomes *in'*, a change typical of South Wales.
Hell	'ell	Initial *h* dropped is typical of South Wales.

Character Notes

The buoyancy, simplicity and joyousness of the Welsh nature come through vividly, especially in Nos. 2 and 3. There is a private Welsh humor too, subtly present in all the examples, notably in No. 1. The ingenuous character of Johnny and his mum is also typical.

The direct, leaping inflections, and the musical variations in pitch and rhythm both make the dialect unique and underline these character qualities. Use them to strengthen the Welshness of any Welsh role you may play.

Recording

Dylan Thomas: The Caedmon Collection, HarperAudio

Plays

The Corn Is Green	Emlyn Williams	Morgan, others
Dylan	Stanley Michaels	Dylan, Caitlin
Henry V	William Shakespeare	Captain Fluellen
Under Milk Wood	Dylan Thomas	Most characters

NORTH BRITISH

NORTH BRITISH NO. 1

The Moors Are Quiet-Like (Speaker: Stephen Nuthall)

(Where were you born, Steve?)
I was born in Woolerton, Nottingham, England, in 1947, the twenty-fourth of July./
(And did you live there when you were young?)
Yes, I've lived there all my life.//
And the house is a detached house;/

childhood
delight

and originally we had a stream RUUNNING through the
garden; so this was a real CHAALDHOOD DELAAT.//
The people who are broad Nottingham, as it were,/
tend to speak slang, as it were,//
Their words, rather than having an accent, are slang words./
(Give us a sample.)

note the short a

A SAMPLE?//
(That would be lovely.)
Well, they use "like" in a number of contexts:/

(Spaced section on CD begins here.)

duck

Ha' yeh been down to t' shops, LAAK?/
Are you going 'cross road, DUUK?//
And things LAAK this:/
Yorkshire; it's SUUMTHING—SUUMTHING LAAK,//
they talk a little bit LAAK this:/
and, uh, they LAAK, they LAAK goin' on t' moors, Yorkshire
moors and—//
places, places LAAK this around, around Yorkshire;/
'cause it's, it's NAAS CUUNTRYSIDE, y' know;//

quiet-like

and we LAAK it round there, because it's QUAAT,
QUAAT-LAAK;/
in weekend; and we get away for t' weekend;//
and have a RAAT good TAAM; RAAT good TAAM;/
yes, UUP in t' moors, and so forth,//
and we're, we're ready for t' start of week, you know.///

NORTH BRITISH NO. 2

The West Bromwich Accent (North British Versus West Bromwich
[Midlands] Accent) (Speaker: Stephen Nuthall)

It was interesting, the last time I was there, we got—/
it was a play from West Bromwich,//
it was based on this, the situation was set there./
And it was—(You don't remember the name of it, do
you?) and it was to do with this, I can't remember it JIST
offhand;//
but it was a comedy, and it was really QUAAT FUUNY./
And the accents there were all in a sort of broken
Birmingham, West Bromwich style;//

which was, you know, we got, we got the speech CUUMING through the NEOS;/

and it was all—all this sort of TA-ALK!//

it really was, you know; this was intentional./

And I suppose you do get QUAAT a few plays which depict, as it were, a particular dialect.///

NORTH BRITISH NO. 3

Children in Wakefield, Yorkshire
(Speakers: Susan Shorter, Leslie Lace, Sally Nuthall)

I am Susan Shorter; I live at NUUMBER WUUN, Robins Grove; I am eleven./ *number one*

I 'AVE two BRUUTHERS, WUUN called Matthew, and WUUN called MAAK.// *Mark*

MAAK is nine, and Matthew is three./

MAAK goes to Church of England school, and Matthew 'ASN'T started school YETT.//

I'm Leslie Lace./

I've WUNN BRUUTHER called Steve, and he's four years old; and I've a MUUM and Dad.//

I'm eleven years old, and I live at 2-3 Atwood Lane, which is a post office./

Well, the dinners, used to be six and a 'ALF pence,//

and now they've gone UUP to sixty pence, which is—/

(Six-and-a-half pence for the whole week?)

No, for a day.//

(Oh I see.)

And, um, it's gone UUP to sixty pence a week now;/

and SUUM people are 'AVING SANGWICHES because they CA' afford that MUUCH.//

NORTH BRITISH NO. 4

In a Yorkshire Pub (Speaker: George Imrie)

Well, it was LAAK this 'ERE./

We got a whole BUUNCH a' fellas that were down a pit,//

and it were WUUN a' them RAAT BLUUDY days when *right, bloody*
every god-damned thing went wrong./

And well, gaffer, 'E'D been down, and E'D been complainin' that it weren't gonna work right,//

we weren't gettin' the RAAT amount a' coal UUP./

Anyway, we decided it were coming on for quitting time, 'n we were going UUP t' PUUB.//

Anyway, we went UUP in t' CAY-YGE, we went UUP and got showered./

After we got showered, got us clean clothes on;//

well, we went over to t' Loyal Trooper in 'AMPSTON./

That's a RAAT good PUUB there!//

*bugger** And the landlord, E'S a RAAT good BUUGGER, 'E is./

pint And I don't know, but if ever a man pulled a fair PAANT, 'E did.//

So, uh, we got goin' over there, and we got talkin' about

Harry them 'ORSES, and old 'ERRY Turner came in. ///

Well now, 'ERRY Turner, 'E was a RAAT WUUN, 'E was;/

'E could make more BLUUDY money on 'ORSES than 'E ever could workin' UUNDERGROUND.//

Anyway, 'E went over there, 'n 'E were givin' us a few tips for t' next day./

So we got chattin' by-and-by; and anyway, SUUM of his pals came in.//

And there was that there DAY-AYVID, now DAY-AYVID, 'E'S a RAAT WUUN, 'E is./

miner *'E used to be a MAANER, but 'E got toffee-nosed about*

education *it all, 'n 'E quit, 'n 'E went and got himself a EDU-CAY-AYSHUN.//*

wire *And after a while, 'E got into the steel WAAR industry, in t' steel ropes./*

hewing *And 'E'S makin' more BLUUDY money than all of us workin' UUNDERGROUND, 'EWIN' BLUUDY coal,//*

sweatin' UUS GUUTS out, and there 'E is drivin' a great big fat car.///

And 'E CUUMS int' t' PUUB; 'E'S into t' PUUB five o'clock at night/

and he doesn't leave till 'ALF-past nine in t' mornin'.//

Anyway, 'E were there, 'n we were tellin' 'IM about us all COMPLAY-AYNTS and what we were goin' t' do wit' Union meetin'/

*Bugger: fellow.

"CUUM on, fellas," 'E says, "For Chris' sake, forget about it." 'E says, "I'll buy you all a drink."//

Anyway, David says to t' landlord, "CUUM on," 'E says. "Stand 'em all around," 'E says. "A pint o' bitters for every man in 'ERE." So we all 'AD a pint o' bitters, 'nd,/

y'know, after a while things seemed a little bit better, and we start' a game o' DA-ATS.// *darts*

And then SUUMWUUN says, "Well, CUUM on, landlord, what about some CHEE-ESE?"/

So AW RAAT, 'E produced some Cheddar cheese, 'E said it weren't too bad.//

It weren't RAAT sharp, but it, you know, weren't too bad./

So then we said, "AW RAAT, we're gonna have some more beer."///

Well then, we decided that we'd all put 'ALF a crown in t' CUUP and so we put 'ALF a crown in CUUP apiece and we started to SUUP./ *sup*

'E says, bimeby 'E says, our worries got less and less and less and less; 'E says, 'n we did this a TAAM or two, a TAAM or two.//

And then we started a little mild bit of singsong, y'know./

We sang one or two YAW-AWKSHIRE songs, and things got a bit rowdy.//

'N then, Ah don' know, 'E said that time seemed to pass awful damn fast./

Next thing 'E said—was saying, "Time, gentlemen, please, time, gentlemen, please, let's 'AVE your glasses, let's 'AVE your glasses."//

'N we didn't take no BLUUDY notice of 'IM: well, we weren't doin' nothin' wrong; we were just bein' in there 'AVIN' a RAAT good TAAM, you know./

And then 'E said, all of a sudden 'E said, "I saw all them Bobbies* in 'ERE."//

Well, there were a great big SAH-AHGEANT sayin', "Now then, what's goin' on around 'ERE? 'S about time you fellas got out of here, ain't it?"/ *sergeant*

*Bobbies: policeman.

And we looked UUP and Blimey! it were quarter t' eleven and t' BLUUDY closin' TAAM were ten o'clock.//

And it's no BLUUDY WUUNDER we were all in TRUUBLE!/

Anyway, it was very noticeable that that there David 'OLLAND 'AD 'OPPED it.///

Pronunciation Notes

North British dialect is very variable, according to the locality of the speaker. In some places it is much stronger than in others, and might be incomprehensible on the stage.

From the examples on the CD you can adopt some important sound changes general to most North British speech. The change in the short vowel in *cud* to that of *could*, respelled *uu*, is universal. Nearly as common is the change from long *i* to *aa*, as in English Cockney and American Southern.

The vowel change you hear in Maak (Mark), No. 3, is exactly the same as that heard in New England! It may have come direct from Wakefield, Yorkshire, to Wakefield, Massachusetts. You hear it again in *da-ats* (darts), No. 4. However, it is less commonly heard than the other two.

Vowels within a word are often sustained, giving a slow, easy character to the speech: *Yaw-awkshire, chee-ese*, No. 4.

As to consonants, the substitution of *t'* for "the," especially after "on," or "into," is very characteristic.

Vowel Changes

STANDARD	NORTH BRITISH	
come	cuum	Short *u* becomes the vowel *uu* of could.
right	raat	Long *i* becomes *aa*.
mark	maak	Broad *a* before *r* becomes *aa*, as in New England.

Consonant Changes

STANDARD	NORTH BRITISH	
the	t'	See note above.
he	'e	Initial *h* regularly dropped in uncultivated North British speech.
Ing	in'	Also a regular change in uncultivated North British.

Character Notes

Example No. 1 still carries a distinct North British quality, but is the speech of an educated man. Example No. 2 suggests that Birmingham working-class speech is nasal. It is certainly another type of the dialect. The speech of the Wakefield children and particularly the speech of the storyteller of the Loyal Trooper pub are good models for most of the roles written in this dialect.

Recording

Monologues...and More!, Stanley Holloway, Avid (UK)

Plays

Billy Liar	Willis Hall and Keith Waterhouse	All characters
Live Like Pigs	John Arden	All characters
Love on the Dole	Ronald Gow and Walter Greenwood	All characters
Roots	Arnold Wesker	All characters
Serjeant Musgrave's Dance	John Arden	All characters

SCOTTISH

SCOTTISH NO. 1

Playing Charlie in *Brigadoon* (Speaker: Brian McKay)

I was BORRN in Greenoch, Scotland./
I'd like to talk just a little BI' about the FIRRST time that *bit*
I realized//
that my dramatic society, the dramatic society I've been in for about four years,/
had decided to do BRRIGADOON.//
Well, you can, you can imagine my surprise/
and HAHPPINESS at DISCOVERRING that BRRIGADOON was the chosen dramatic for that year.//
I began of course immediately DETAIRRMINING what *determining*
role I would like to play. Would I like to play the lead?/
Well, no, because if I played the lead, I would have to play an American role.///
So I thought, Well now, what is the sense of that?/

Here I am with my Scottish HERRITAGE, my Scottish accent,//

and I'm going to be allocated the role of an American in a Scottish play!,/

Well, I thought, that's just a BI' ABSURRD, so I thought,//

No, I'll play the part of CHARRLIE DALRRYMPLE. Now I'd set my mind on CHARRLIE./

out *And sure enough, I went OHT,//*

and I auditioned for the role, and I was given the role of CHARRLIE!/

down *So of course my job was cut DOHN just a little bit from perhaps an American//*

formulate *attempting or beginning to FORMULAY' or dramatize the role of CHARRLIE DALRRYMPLE./*

I didn't have to LAIRRN the accent,//

which was a definite advantage.///

(The spaced section on the CD ends here.)

This song is from the show BRRIGADOON, and it's done as it was done in performance./

The song is entitled "Come to Me, Bend to Me."* //

Although they told me I can't behold ye
Till when the music starts playin',/
To ease my longin', there's nothin' wrong in
Standin' OHT here and sayin',//

O come to me, bend to me, kiss me good-day.
DARRLIN', my DARRLIN', that's all I can say!/
Please come to me, bend to me, kiss me good-day!
Give me your lips, and don't take them away.//

Come, DEARRIE, near me, so ye can hear me,
I've got to whisper this softly./
Although I'm BURRNIN' to shout my YEARRNIN'.
The WURRDS come tiptoein' off me.//

O come to me, bend to me, kiss me good-day!
Give me your lips, and don't take them away.///

*From *Brigadoon*, by Alan Jay Lerner.

Perhaps I'll talk now just a little BI' ABOHT SAIRRTEN *about certain*
CAATCH or key phrases used in the Scottish pronunciation,/ *catch*
 idiosyncracies, if you will, of a Scottish dialect or accent.//
 Of COURRSE the r's are the most PRROMINENT particular
aspect of the Scottish accent./
 The r's are RROLLED, as it were; for example, the WURRD
BURRNIN'or YEARRNIN'or I HAIRRD it.// *heard*
 This brings up another point, the strange pronunciation of
the vowel in the WURRD *HAIRRD*, as the Scotch say it./
 Perhaps another one is the strange or the different pronuncia-
tions of WURRDS in contrast to the American pronunciation.//
 For example, the Scottish phrase to indicate that one is
leaving./
 For example, I would say, *AAM G'N OOT*, rather than *I'm going out*
I am going out.///

SCOTTISH NO. 2

*Good-bye, Mr. Muldoon** (Speaker: Barbara Karp)

 Oh, MISTERR Muldoon! Aye, oh, ye mustn't talk like
that, sir!/
 But WHIT way^e should we no' meet again? WHIT way *not*
no'?//
 Ah, but ye must come down and see the FARRM./
 I want ye to know Sandy, I want Sandy to know ye.//
 He will be awful pleased to make your acquaintance./
 I know he would be VERRA VERRA grateful to ye for
bein' so good to me on the ship.//
 Oh, you were, you were awful kind. Well, you helped me
with my luggage, and ye gave me books to RREAD,/
 and ye told me many many things ABOOT America so that
I don't feel STRRANGE.///
 And I'm awful glad to have a FRRIEND in this GRREAT
country./
 And I hope you'll come down.//
 I will, I will NE'ERR forget you./
 Well, I wish ye great success with YERR WURRK, and
I hope ye'll have health and happiness always.//

*From *The Art of Ruth Draper* by Ruth Draper.

Aye, I PRROMISE; and I hope you'll come down to the FARRM, and pass the day./

grading I know Sandy would be GRRAIDIN'[f] to know ye. Aye, I have your address, and I'll write ye, I will.//

Well, I will NE'ERR FORRGET you. Good-bye, MIS-TERR Muldoon, good-bye.///

SCOTTISH NO. 3

From "To a Mouse," by Robert Burns
(Speaker: Jamie Copley)

cowering, timorous Wee. Sleekit, COWRRIN' TIM'RROUS beastie,/
breastie (breast) Oh, what a panic's in thy BRREESTIE!//
so Thous needna start awa' SAE hasty
 Wi bickering brattle![g]/
 I was be LAITH[h] to RRIN and chase thee
 Wi' MURRD'RRING pattle![i]//

 I'm TRRULY sorry man's dominion/
 Has BRROKEN Nature's social union,//
 And justifies that ill opinion
 Which makes thee STARRTLE/
 At me, thy poor EARRTHBORN companion
 And fellow-MORRTAL.//

* I doubt na', whyles,[j] but thou may thieve./*
* What then? POORR beastie, thou MAUN[k] live!//*
* A daimen icker in a THRRAVE[l]*
* 'Sa SMA' request./*
* I'll get a blessin wi' the lave[m]*
* And NEVERR miss't!//*

SCOTTISH NO. 4

From *True Thomas*, a Scottish ballad
(Speaker: George Emmerson)

 TRRUE Thomas lay on Huntley Bank;
fairy, eye A FAIRRLIE he spied with his e'ee./
 And there he saw a lady BRRIGHT
down Come riding DOHN by the Eildon Tree.//

HERR SKURRT *was o' the* GRRASSGRREEN *silk,*
HERR *mantle o' the velvet fine./*
*At ilka tet*ⁿ *o' her* HORRSE'S *mane*
Hung fifty SILLERR *bells and nine.//* *silver*

TRRUE *Thomas he* POO'D *off his cap* *pulled*
*And touted*º *low* DOHN *on his knee./*
"Hail to Thee, Mary, Queen o' Heaven!
For they PEERR *on* AIRTH *could never be."//* *peer, earth*

"Oh no, oh no, Thomas," she said.
"That name does not BELANG to me./
I'm but the Queen of fair Elfland,
That am HITHERR come to visit thee./

"HARRP and CARRP,ᵖ Thomas," she said, *Harp*
"HARRP and CARRP along wi' me./
And if ye DAIRR to kiss my lips, *dare*
Sure of YOURR body I will be."//

"Betide me weel, betide me woe,
That WEIRRD�q shall never dauntenʳ me!"/
Syneˢ he has kissed her rosy lips
All underneath the Eildon Tree.///

Pronunciation Notes

As Brian MacKay, the speaker in No. 1 says, the rolled *r* in Scottish dialect is the most prominent sound change. In these examples, as in real life, it varies very much in intensity. You hear the best and clearest example of it in No. 3, *rrin* (run). Other good examples on the CD are: *burrnin'* (No. 1), *farrm* (No. 2), *starrtle* (No. 3), and *grrassgrreen* (No. 4). It is respelled throughout all the examples, whether stronger or lighter, with the same double *r*, *rr*.

To make it, practice blowing a trill over your tongue, keeping the tip loose: BRRRRR! The sound is easiest to produce following a *b*. To use it in the dialect, shorten it appropriately. When playing and saying the examples, match the length of the trilled *r* with that you hear in each instance.

The vowel change of *er* as in "her" to *air* as in "hair" is also an important change, particularly for Lowland Scottish, to which these examples belong, with the exception of No. 4, which is closer to the Highland variety. Highland Scottish is especially musical and expressive, having a Gaelic melody similar to that of Welsh and Irish; all three

are related to Celtic languages. Base yourself on the special qualities of No. 4 if you should have to play a Highland role.

In No. 3, the rich Lowland accent used by the speaker is authentic Perthshire Scottish. You are not likely to have to reproduce phrases so unfamiliar to the general audience. Play and say them for sheer enjoyment of the vivid native images, crammed into a few syllables: "A daimen icker in a THRRAVE's a sma' request!"—meaning, One single ear of corn (stalk of wheat) in twenty-four whole sheaves is little to ask!

The vowel change of *ow* to *oh* or even to *oo* is variable. In No. 2, *aboot* is heard for "about." But at the beginning of No. 1, "about the first time," the "about" is very slightly different from standard, too slight to respell. However, at the end of No. 1, the speaker calls "out," *oot*. The best example is in No. 4, "come riding dohn [down] by the Eildon Tree." Do not make the mistake of adopting an easy change from *ow* to *oo* when using Scottish dialect on the stage. Rather keep to the light *oh* for *oo*, and make the other harder changes along with it.

Vowel Changes

STANDARD	SCOTTISH	
determine	detairrmine	*Er* becomes *air*.
Down	dohn	See note above.
out	oht or oot	

Consonant Changes

STANDARD	SCOTTISH	
run	rrin	R is rolled or trilled. See note above.
bit	bi'	
formulate	formulay'	In regional Glasgow area Scottish, the final *t* is often dropped, and a slight jerk (the glottal stop) substituted.
Loch	Locch	Not heard in these examples, but a common consonant change. Final *ch* is pronounced like the guttural German *ch*, as also in Welsh. See p. 93. It may also be heard in *nicht*, "night."

Character Notes

Scottish characters in plays are usually straightforward types—the men strong-willed, dogged, with unshakable loyalties and absolute principles. Read the stage direction of Sir J. M. Barrie's *What Every*

Woman Knows; the play is an essay on Highland men of that breed. Notice also the direct approach of the speaker in No. 1 to what he wants: "Now I'd set my mind on Charrlie!" When a Scotsman sets his mind, he sets it to stay.

Read also the whole of the late Ruth Draper's famous monologue, "The Scottish Immigrant," in *The Art of Ruth Draper* from which No. 3 comes. The portrait of Leslie MacGregor, the fresh, warmhearted Scots lass, is a true one. The character would serve as a prototype for any of Barrie's heroines, or any ingenue Scottish role.

Plays

Armstrong's Last Goodnight	John Arden	All Armstrongs, servants
In the Zone	Eugene O'Neill	Scotty
John Knox	James Bridie	All characters
The Old Lady Shows Her Medals	Sir J. M. Barrie	Mrs. Dowey, Dowey
Riel	John Coulter	Rabbie
What Every Woman Knows	Sir J. M. Barrie	Alick, Wylie, David, James, Maggie, Mr. Venables

Musical

Brigadoon	Alan Jay Lerner and Frederick Loewe	Charlie Dalrymple, Fiona MacLaren, Jean MacLaren, Mr. Lundie, Meg, Brockie, others

CD THREE

IRISH

IRISH NO. 1

From *In The Shadow of the Glen* by John M. Synge[t]
(Speakers: Radio Eireann Players)

Good evnin' to you, lady of the house.
Good evnin', kindly STHRANGER./
It's a wild night, God help you, to be out, and the rain
FAHLLIN'.//

It is, SURRE-LY, and I walkin' to Brittas from the

Aughrim AHCCHRIM fair./

Is it walkin' on your feet, STHRANGER?//

On me two feet, lady of the house,/

and when I saw the light below,//

I T'OUGHT maybe if you'd a sup of new milk and a

quiet, decent QUYTE, DAYCENT corner where a man could—/

Lord have mercy on us all!//

Ah, it doesn't matter anyway, STHRANGER. Come in out
of the rain.///

Is it DEPAR-TED he is?/

It is, STHRANGER.//

He's after dyin' on me, God forgive him,/

and there I am now with a HUUNDRED sheep beyond on

no the hills,// and NAW TURRF drawn for the winter./

It's a queer look is on him for a man that's dead.//

He was always queer, STHRANGER,/

and I suppose them that's queer when they're livin' men
will be queer bodies AFTHER.//

Isn't it a great WUUNDER you lettin' him lie there, and
he not tidied or laid out itself?/

I was afeard, STHRANGER,//

for he put a black curse on me this MARNIN' if I touch
his body the time he'd die sudden,/

only *or let anyone touch it except his sister AWNLY,//*

and sure it's ten miles away she lives in the big glen

over *AWVER the hill./*

It's a queer story he wouldn't let his own wife touch him,
and he dyin' QUYTE in his bed.//

He was an AWLD man, and an odd man, STHRANGER.///

IRISH NO. 2

From *The Playboy of the Western World* by John M. Synge
(Speaker: Christopher Johnson)

It's the will o' God, I'm thinkin', that all should win an
easy or a cruel end./

And it's the will o' God that all should rear up lengthy
families for the nurture of the earth.//

Now what's a single man, I ask you? Eatin' a bit in one house, and drinkin' a SUUP in another./ sup

And he with NAW place of his AWN like an AWLD brayin' no, own, old
jackass STHRAYED upon the rocks.///

It's many would be in dread to bring your like into their house for to end them MAY-BE with a sudden end./

But I'm a decent man of Ireland, and I'd liefer face the grave untimely, and I seeing a score o' grandsons growin' up little gallant swearers by the name o' God,//

than go peoplin' my bedside with PYOO-OONY weeds the puny
like of what you'd breed I'm thinkin' out o' Sean Keough./

A darin' fellow is the jewel of the WORRLD, and a man that did split his father's middle with a single clout should have the bravery o' ten.//

So may God and Mary and Saint Patrick bless you and increase you from this MORRTAL day.///

IRISH NO. 3

Marty and Judy (An Improvisation)
(Speakers: Martin Anderson, Judith Doble; follow the spacing for each speaker separately)

DARRLIN', where are you goin' AFTHER this?/
Oh, I'm not tellin' ye, MARRTY./
You better tell me, I want to know where you're goin.//
Why for?//
Why for? I oughta know where you're goin', shouldn't I?/
I can't think of any reason why you should know where I'm goin'./
I can't think of any reason why I shouldn't know where you're goin'.//
Well, I'm not sure where I'm goin'.//
Oh, you're not sure, are you?/
No./

I bet you know where you're at. Where 'r ye goin? Let me
see your SHEDYULE.// schedule
Don't you look in there, MARRTY.//
Why not? I want to know where you're goin'!/
This is my private business!////
Who're you goin' to meet? Who're you goin' to meet? Have
INNY–? I bet you're givin' the eyes to Case over there!//// any

IRISH NO. 4

From *Cock-a-Doodle Dandy* by Sean O'Casey
(Speaker: Allan J. Gruet)

Get into th' house, man, and don't be standin' there in that style of half-naked finality!/
You'll find some AWLD trousers upstairs.//
You two hussies, have you no semblance of things past an' things to CUUM?/
Here's a sweet miracle only AFTER happenin', and there's y'are,//
 gigglin' and gloatin' at an aspect in a man that should send the two of youse screamin' away!/
Youse are as bad as that one possessed the PEO-PLE call me daughter.///

IRISH NO. 5

Born in Donaghadee (Speaker: Peter Gibson)

Donaghadee
Belfast

Strangford
Loch

I was BORRN in DUNACCHADEE, in NORTH'RN Ireland, which is near BELFAAST, where I live./
DUNACCHADEE; D-O-N-A-G-H-A-D-double-EE, DUNACCHADEE.//
To the south of DUNACCHADEE is STRAANFORD LOCCH,/
which has taken its name from Danish origins because it is where the Danes LAANDED in NORTH'RN Ireland, uh, many hundreds of YEARRS AGO. //
And it's got a very NAARROW inlet and that's why it was called STRAANFORD; and it has strong currents at the inlet./
But at the top end it's got very wide beaches, and at low tide, I think up to half a mile or even more of SAAND is exposed.//
And at the north end of the LOCCH is NEWTON Arms, a town where my parents and most of my relations were BORRN./
It's about twenty miles from BELFAAST.//
We have a page in our SATURRDAY evening newspaper in BELFAAST,/

which is "This Week in Ulster," and it's billed as "The Page That Makes Sunday Morning Reading in Toronto,"//

because it's sent abroad; and my parents have cut it out and sent it over to me;/

and AWN the back of this there is a feature called the "John Pepper Column"—people sending in phrases and what they actually mean.//

ANNY MOO-ER means *any more*; SEX is teatime in Ballymena, which is a town in Antrim;/ *six*

and a crash is a motor accident on the Malone Road,//

which is the upper-class PARRT of BELFAAST, a crash as opposed to a CRAASH.///

One o' the most, I think, important plays that has been in NORTH'RN Ireland in recent years is one called Over the Bridge by SAAM Thompson./

SAAM Thompson I think now is DAAD.// *dead*

It is a play about the shipyard and BELFAAST, and about shipyard WURRKERRS;/

and actually the play, which was put AWN about a year or so ago in the Lyric THAYTER.//

which is about the only THEE-AYTER of note in BELFAAST./

Two THAYTERS which put AWN sort of light things have closed down.//

They used AACTUAL shipyard men for walk-on parts;/

a Catholic WURRKER is mobbed by Protestant WURRKERS, and shipyard men were used for this fight.//

And as a result of the fight the foreman is killed, and some WURRKERS are BAADLY injured./

And the whole ending of the story is sort of in TRAAGEDY.//

But like O'Casey it has its moments of comedy.///

DUNACCHADEE—there's an old song, "Toorala, Tooralee, For it's six miles from Bangor to DUNACCHADEE."/

The song's set in the County Tyrone, which is nothing to do with DUNACCHADEE, but the refrain comes in—//

In the County Tyrone in the town of Dungannon
There was many a ruction meself had a han' in;/
Bob Williamson lived there, a weaver by trade,

And all of us thought him a stout Orange blade.//
On the twelfth of July as it yearly did come,
Bob played with his flute to the sound of the drum./
You can talk of your HARRP, your piano or lute,
But none can compare with the OWLD Orange flute.//

Tooraloo! Tooralee! For it's six miles from
Bangor to DUNACCHADEE.///

Pronunciation Notes

Irish melody is the most essential part of the dialect. Consonant changes are important, but difficult to represent in respelling. The sound of *th* replacing the *t* in "stranger," "after," and similar words, is not really a *t*; it is between a *t* and a *th*. Listen to the sound in No. 1. Then make the *th* just above the inside of your upper teeth, keeping it light and unobtrusive.

The guttural *gh* in Donaghadee (No. 5), is respelled *cch* here, as in the Welsh examples. You hear the same sound lightly in Aughrim (No. 1). It is spelled *ch* in Scotch place names, such as Loch Lomond.

The Irish *r* is very lightly trilled, much more lightly than in the Scottish examples. Use too little of the trill rather than too much for an Irish role.

As to vowels, the most distinct change you hear is *daycent* for "decent" and *thayter* for "theatre." Consider these as *idioms* more than as *sound changes*. This change occurs only in certain words, of which there are not many.

O (oh) changes to *aw*, not to the American *ow*, though this is often heavily used in an assumed Irish dialect. Listen carefully to the examples of this change, especially in No. 1: *naw turrf: his sister awnly; he was an awld man*. Use this sound rather than the one you hear in the song at the end of No. 5, about the *owld Orange flute*.

The musical inflections are vital; this too is a language stemming from a Celtic tongue. Listen to the melody of the dialogue from *In the Shadow of the Glen*. Take time to learn it. Listen also to the voices of Siobhan McKenna and Cyril Cusack in the recording of *The Playboy of the Western World*, listed at the end of this section. The dialogue was written for exactly such cadences as these.

The northern Irish speech of the speaker of No. 5 is that of an educated Irishman, still speaking with a residual Irish quality that he will probably retain through life.

Vowel Changes

STANDARD	IRISH	
decent	daycent	See note above.
theatre	thayter	See note above.
old	awld	See note above.
sup	suup	The same change as in North British, the short *u* of *cud* to the sound in "could."
quiet	quyte	Occasional; not heard elsewhere on the CD.
narrow	naarow	Short *a* becomes middle *aa*, especially in North Irish.

Consonant Changes

STANDARD	IRISH	
Aughrim	Ahcchrim	See note above.
stranger	sthranger	*Tr, dr, ft* change *t* toward *th*.
surely	surre-ly	*R* is slightly trilled; the syllables are divided in this word.

Character Notes

Because of the number and variety of Irish plays, this dialect may be in great demand. Base your adoption of Irish English generally on No. 1. For contrast, learn the North Irish variety of No. 5, and see if you can switch from one to the other. Improvise freely; use novels written in a respelling of the "brogue" as practice material; and continue with dialogue from any of the plays listed below.

Plays

The Far-Off Hills	Lennox Robinson	All characters
Juno and the Paycock	Sean O'Casey	All characters
The Old Lady Says "No"	Denis Johnston	Sarah, Katie, Lizzie, others
Philadelphia, Here I Come	Brian Friel	All characters
The Playboy of the Western World	John M. Synge	All characters
The Rising of the Moon	Lady Gregory	All characters
The Quare Fellow	Brendan Behan	All characters

The Moon in the Yellow River	Denis Johnston	All characters
Cock-a-Doodle Dandy	Sean O'Casey	All characters
Sticks and Stones	James Reaney	All of the Donnellys; several of the neighbors

END NOTES

[a] In Cockney and in the British dialects following, respellings are not used for broad *a* in "can't," and other vowels and consonants regularly different from American pronunciations. They should, of course, be adopted with the other variants. See the comment on page 71.

[b] Caedmon Records, TRS 319.

[c] Bach, a term of endearment.

[d] Hares bounding.

[e] Whit way, why.

[f] Grading: wanting.

[g] Brattle: hurrying run.

[h] Laith to rrin: loath to run.

[i] Pattle: plough spade.

[j] Whyles: sometimes.

[k] Maun: must.

[l] A daimen icker in a thrrave: an ear of corn in twenty-four sheaves.

[m] Lave: remainder.

[n] Ilka tet: every braid.

[o] Louted: kneeled.

[p] Carrp: carp, to chat (obsolete).

[q] Weirrd: destiny.

[r] Daunten: daunt.

[s] Syne: soon.

[t] Spoken Arts Records, SA 743.

7

EUROPEAN ACCENTS

In this section, pronunciation and character notes will be discussed under the same heading.

FRENCH

FRENCH ACCENT NO. 1

Dijon and Paris
(Speaker: A French woman from the French consulate in Boston)

Well, ah, Dijon is, I would say, DER small CEETY./
DER, DER HROAD are very NAHROW.// *the roads,*
And DERE we, uh, have DE SPECIALITY of Dijon is *narrow*
MUS-TARD,/
mustard and escargots de Bourgogne.//
And we have a soy cake that we call Panapis, but here
nobody knows about THEES cake, you know./
Dijon is like, well, a small CEETY like VAIRMONT, *Vermont*
I would say;//
VAIRMONT, more VAIRMONT in Maine, you know./
HROAD are very NAHROW, and, uh, very HISTORI-CALL;
is a very very old CEETY.///
Well, yes, PAREES is like New York, very very FES', in *fast*
our life./
People come work, go work, come back, go out,//

113

and they go to cabarets, you know, like Folies Bergère and the Lido./

another It's 'NUDDAIR place to go to see.//

And I THEENK that people want to go every night,/

because a CEETY, you know, a wild CEETY like New York, you know, you want to go every night. You don't care if you work hard, or—//

Well, I went to Folies Bergère one, once, when I went in PARISS,/

and DERE, you know, DEY have a big, big theatre, and—//

at least, I would say, two hundred la-(dies), girl, you know, beautiful beautiful girl, almost nude,/

and they, you know, on the stage, doing show.//

are *And every two minutes, you know, DEY AHR in MEB-BEE gold,/*

red *and a few minutes AF-TAIR DEY will be in HRED,//*

not, uh, making another PAIRFORMANCE, you know.///

FRENCH ACCENT NO. 2

No Bus for Bridgewater (Speaker: Alain Habert)

thought *...because I arrive in nine o'clock; and I SOUGHT ZERE is still a bus for BRIDGEWAT-ERR,/*

because I did not SINK that it's very far.//

but Bridgewater was, is, very far, no?/

(Yes, it's quite a way, a distance.)

Trailways *So, no bus; and, uh, service man of TRELL-WAY said me ZAT for taking cab, twenny, twenty DO-LLARS!//*

So I 'AVE one 'UNDRED DO-LLARS, so if I take cab— hoola!/

So I go, uh, outside; and I SOUGHT that I, maybe I can sleep in a DORMITOR-EES in a UNIVERSI-TEE, because—//

easily in France you can IZZILEE sleep in DORMITOR-EES;/

and you 'AVE to pay only, for instance, mmm, (few francs?) yah, very LEE-TULL.//

And in France you have ALL-ZO auberge de jeunesse,
youth inns yous EENS, yeh, it's free./

So it's BET-TAIR. (Marvelous.)///

But in AMERICA, I did not afford zee 'OTEL, or because it's too EXPEN-SEEV;/

because I 'AVE WIZ ME, WHEN I arrive I 'AVE WIZ me one 'UNDRED and fifty DO-LLARS.//

So I 'AVE to save all ze money I can!/

(Where did you stay last night?)

Oh, but I met KASSY and a boy friend of his [hers] in the STRAIT,// *Kathy street*

And I asked for ZEM EEF EET'S POSSI-BLE to sleep in a DORMITOR-EE,/

and if ZERE EES a DORMITOR-EE AHROUND ZE CEN-TER.//

But they said me in the beginning that there is no dormitories in ZE CEN-TER of ZE cities;/

and after, she said me that she has, uh, an apartment with several girls in your COLL-EGE.//

And she can receive (put you up?) receive me; and I accept!/

(What will you do after today—will you stay in Boston?)

Oh, stay in Boston several days, EEF I can,//

for visiting, I would like to visit Boston because/

all ZE Americans said me that Boston is very WON-DER-FULL,//

in New York, in New Brunswick, in PHILADELPH-YAH, Cleveland, people said me, "Oh! Boston, WON-DER-FULL! So!////

FRENCH ACCENT NO. 3

A French woman Looks at Boston (Speaker: Jeanne Colony)

I'm going to tell you what I, what a few of my impressions of BUS-TUN./

I mean, it's to me, it's a RAZZER STRENDGE town.// *rather strange*

I'd imagined it RAWTHER differently;/

and EET'S not really an American town for me;//

EET'S a very funny MEEXSHER of America, of course,/ *mixture*

but also ENG-LAND in many ways;//

and in some other ways, and THEES you might not understand, Clermont-Ferrand of the nineteenth century./

And Clermont-Ferrand is a VERREH VERREH boring *very*
town in FRAHNCE, and VERREH stuffy.//

And all THEES EES BUS-TUN for me, MEEXED up with the marvelous side of it, which are the UN-I-VER-SIT-AYS./

And EET'S all like a BEEG MEEXSHER of things which I really can't define VERREH well.//

Sometimes EET'S beautiful and blue and SUN-NAY; sometimes EET'S absolutely GHAHSTLY.///

FRENCH ACCENT NO. 4

Good-bye to Paris (Speaker: James Sherwood)

Today I've been living here in PARISS for a long time, a year and a half, almost,/

and today I'm going away; I go to Rome; and then afterwards I go to New York.//

And I 'AVE to say good-bye to my friends here, which is DEEFICULT, and a little sad./

I do not HREAD very well when I speak French, and I find something interesting.//

It is that when I am reading French, when I am reading English here, WIZ ZIS PA-PER,/

If I speak like ZIS, I find it more difficult to choose my words;//

almost as if I were French, trying to speak English./

Because once one starts with his AC-SONT, ac-SON, whatever you want to say,//

there is a rhythm—a rhythm that one falls into naturally./

My name is PATREEK, I LEEV in PAHREES, do you speak ENG-LISH?///

This is a classic French accent./

When I speak French, I speak with an AC-CENT—in French; which is also interesting for a Frenchman.//

When I was here I did, I tried to do some accents for them in the UNIVERSI-TAY; I worked here for a long time./

It's been a very good, very good experience here.//

The sky in Paris is beautiful today; the sky is—it HRAINS always in Paris./

You know, I think the—I think the legend about the fog in London—it must have been made by a Frenchman.//

Because the weather in Paris is always always awful—frightening./

In any case, tonight I leave, and I am very sad. Au revoir! goodbye; so long, BE-BEE, as they say HEAH, so long, BE-BEE;//

In one week I will be home, in the United States; and I shall always come back HEAH; because this also is my home now.///

Pronunciation and Character Notes

The distinguishing elements of French accent are two: the accent generally carries the stress of a word over to the last syllable, and it changes short *i* to a short *ee* sound.

The change of stress happens whatever the number of syllables in a word; two, mus-*tard*; three, expen-*seev*; four, Philadelph-*yah*; and five, universi-*tay*. Listen to every instance of it in these examples, to guide yourself in using it in speeches to which you will apply the accent.

The *ee* which you substitute for *i* should be a short *ee*—the first *e* in "receive," not the second. Though the four examples differ from each other in several respects, this change is common to them all. Make it habitual for French accent, but keep it light.

Other changes are the change of the *th* to *z*, as in No. 2, or to *d*, as in No. l; and the change of *r* to the uvula *r*, respelled *hr*. If you speak French with a good accent, this will be easy for you to accomplish. If not, listen closely to the sound, so apparent in No. 1, in "narrow" and in "road(s)." Try to get it by saying *hr* at the back of the throat. Or simply do not try to use it as a part of your accent.

The types of speakers and their backgrounds are apparent in the material. No. 1 has a provincial quality. No. 3 has British overtones, using words like "stuffy," "ghastly." No. 4 is an American who speaks excellent French, with a consciousness of the relation of French to English pronunciation that is singularly perceptive. His French accent would be applicable to urbane French roles, where the accent is residual. For a stronger accent, and for an effervescent character, volatile and enthusiastic, follow the inflections and pronunciations of No. 2, and adopt *"hoola!"* as your own.

Vowel Changes

STANDARD	FRENCH ACCENT	
think	theenk	Short *i* becomes a shortened *ee*.
after	aftair	*Er* becomes *air*, especially when final.

Consonant Changes

STANDARD	FRENCH ACCENT	
narrow	nahrow	The uvula *r* of French may persist into English.
this	zis or diz	Be consistent with this change, whichever one you choose.

STANDARD FRENCH ACCENT

| hotel | 'otel | Initial *h* is often dropped, being silent in French. |

Stress Changes

Shift the accent to the last syllable where this would have been the case with the corresponding French word.

Recording

Gigi, soundtrack, Rhino

Plays

Becket	Jean Anouilh	King Louis, French barons, servants
Gigi	Anita Loos	All characters
Henry V	William Shakespeare	Princess Katharine, Alice
The Love of Four Colonels	Peter Ustinov	Colonel Aime Frapport
The Watch on the Rhine	Lillian Hellman	Anise
The Happy Time	Samuel Taylor	All except Mr. Frye, Maman (Scottish), and Sally

Musical

| *South Pacific* | Richard Rodgers, Oscar Hammerstein II | Emile de Becque, children |

ITALIAN

ITALIAN ACCENT NO. 1

Life in Rome Is Different (Speaker: Anita Sangiolo)

Now I come from Rome; and I'M-A living in Weston./
Weston is country; you know, the grass, the HOUSES-A, the FENCE-A, but in Rome!//
It's a big city, you know; it's different in Rome; I'M-A used to the city a little more./
We walk a lot, you know? We walk in the streets and we shop a lot.//

Life over there's very different than the life over here, you know./

Yeah, we go SLEEP-A in the afternoon.//

Then we get up about four o'clock, because it's hot over there, you know, in the summer it's very very hot.///

We get up about four o'clock; we go back to school, or go back to work, you know./

In the city, there's a lot of life, until ten, eleven o'clock—//

You know, you WALK-A in the city, you sit down in a café, you have a café, you know, with friends and all that./

But over here! Very different.//

You know, over here, very different.*

(Are the universities the same over there, or do you find them different?)

Well, it's more strict over there./

Now over here, the teacher and the student, they have RAPPORT-A,//

How do you say RAPPORT-A? (Rapport?) Rapport?

They HAVE-A rapport, good rapport, over here./

You TALK-A to the teacher like you TALK-A to your mother, father, your sister!//

But over there, it's—everything is Professore, Signor Professore, si, Signor Pro—/

You know, there's a lot of respect. (More formal?) Yes, si. Very formal.///

ITALIAN ACCENT NO. 2

How to Lose an Italian Accent (Speaker: John Peters)

It seem to me, Signorina Sangiolo, that you speak very well ENGLEESH. I—

Ma l'Italiano lo parla meglio!** (Si capito.***)

You know, if you've been a long time in America, I've been maybe twenty years now, in America,/

and you are a short time, but you are younger,//

and I THEENK it is much easier for you to—to learn to speak without so much accent./

*This line is not repeated in the spaced section.
**Translation: But I speak Italian better.
***Translation: I understand.

You know that is the BEEG THEENG, the accent.//
(Yeah, I cannot think right away, you know?)
You REMIND-A me, what you said, (Yes?) *the FREN-CHA-MAN, he came THEES-A country, he said to another friend,/*
he says: "I speak very GOOD-A now the ENGLEESH: ees very easy for me."//
And the friend tell HEEM, "What about ZEE t-h?"/
bother *He say, "Oh, ZEE t-h; ZAT doesn't BOZZER me!"//*
So you see, the language is a very, is a very complexity./
You never really know in your whole life, anyone can know any language; maybe not even his own.//
EETALIAN, for example, the words come from the dialect./
(Oh, Italian is very musical.)//
You saw the dictionary. (You sing opera?) It's about a foot high, EETALIAN dictionary./
(Yeh, yeh, but in EENGLISH it's very difficult, because you don't read what—you don't pronounce what you see, what you read.)//
That EES right. I understand./
(But in Italia! Anybody could speak Italia!)///

ITALIAN ACCENT NO. 3

On Sunday at the Beach (Speaker: Diane Grudko)

I'M-A gonna tell you what we do on a Sunday, SUMMERTIMES-A./
It gonna be maybe June, maybe July, you know?//
The WHOLE-A family, me, Angelo, the KEEDS-A, we get in the car, we DRIVE-A down to the BEACH-A./
Early, early in the MORNING-A, when the SUN-A SHE'S-A JUST-A coming UP-A.//
I sit on the beach, and the KEEDS-A and the poppa go lookin' for the clams and the CRABS-A./
ABOUT-A twelve or one O'CLOCK-A, when they catch ENOUGH-A, we get back into the car and DRIVE-A HOME-A.//
Then IT'S-A my turn to WORK-A, you know?/
Me, Rosa, she helps me. We cook UP-A the clams and the crabs and the pasta.//
Everybody sits by the table, maybe two T'REE hours, drink a lot of vino./
AN'-A SOMATIMES I MAKE-A the special pastry for dessert.//

IT'S-A very NICE-A, DELICIOUS-A, you know what I mean?/

But IT'S-A fattening; and I'M-A tryin' to KEEP-A my figure; you know?///

ITALIAN ACCENT NO. 4

From *Liola* by Luigi Pirandello (Speaker: John Peters)

Ah-ha, you are CLE-VAIR, I CAN-A see THAT-A./
Me? No, don't be afraid of me, Uncle Simone.//
I don' want ANYTHING-A./
I leave it to you to worry about your money, and STAND-A guard over there with your snakes' eyes darting.//
LAST-A night I SLEPT-A the sleep I LOVE-A . . . /
Come on, then, what's left to do, AUNT-IH Croce?//
The shelled almonds have to be carried into Uncle Simone's shops?/
Forward MARCH-A! Hurry, girls, and Uncle Simone will GEEV us something to DREENK-A!//
Now, WHO'S-A first? THEES one for you, Nela, O.K.?/
THEES-A one for you, Ciuzza. O.K.?//
THEES one for you, Moscardina. Keep your chin up!/
This little one for you, Aunt Gesa.//
And here's the biggest of the LOT-A for me to carry./
Come ON-A! Let's get going, GIRLS-A!//
Let's get going, Uncle Simone!////

ITALIAN ACCENT NO. 5

From *The Rose Tattoo* by Tennessee Williams
(Speaker: Karen MacDonald)

No, I don't mix with DEM women./
The DOMMIES I got in my HOUSE-A, I mix with THEM-A better because they don't make UP-A no lies.//
What kind of women are DEM? "Eee, Papa, eee, baby, eee, me, me, me!"/
At thirty years old, they GOT-A no more use for the letto matrimoniale, no!//
The BEEG bed goes to the basement!/
They GET-A LEETLE beds from Sears Roebuck, and sleep on their bellies.//

They make the life without glory./
*Instead of DE heart, DEY GOT-A DE deep-freeze in DE
house.//*
*DE men, DEY don't feel no glory./
not in DE house wi' DEM women!//*
*DEY go to DE bars, fight in DEM, get drunk, GET-A fat:/
put horns on the women because the womens don't GEEV
DEM DE love which is glory.//*
I DEED. I GEEV HEEM DE glory./
To me, the BEEG bed was beautiful—like a religion.///

Pronunciation and Character Notes

The most noticeable sound change in Italian accent is that heard in *fence-a, talk-a*—the addition of an unstressed neutral vowel to many monosyllabic verbs and nouns. This happens very frequently after the plosives *p*, *b*, *t*, *d*, *k* and *g*, and their plurals. The sound is not a long or a short *a*, though following traditional dialect spelling, it is respelled *-a*. It is the *a* in "sofa," which is really *uh*. Listen to the examples, especially No. 1, to get the neutral quality of this vowel.

As with French accent, the *th* sound is sometimes *z* and sometimes *d*. But in the residual Italian of No. 1, this change does not occur. It is not a change to overdo. As with French, also, short *i* is changed to *ee*; but this change too is absent from No. 1. Short *u* may change to short *o*, or to the sound North Americans use in "watch"; "dummies," *dommies*. Though not heard elsewhere on the CD, it is fairly common; "plum," *plom-a*; "husband," *hozband-a*.

The best examples of Italian inflections on this CD are in Nos. 1, 2 and 3. Listen to the scraps of native Italian that punctuate a bit of the conversation in No. 2. Compare its rippling melody with a similar lilt in the last sentences in Nos. 1 and 2, and in almost all of 3. The query in No. 2, "You sing opera?" is a clue. Most Italians do sing opera; most speak their language, and consequently their English, with rapidly moving, recitative-like inflections. Listen to any Italian opera, and compare the melodies with the liveliest of the speech inflections on the CD. Join in with the speech tunes as you practice. Exaggerate if necessary; but be sure to get the full sweep of the speech pitch intervals, as bona fide Italians do.

American plays with Italian-accented English parts are numerous. The types evident in these five examples relate to many of them. The

American-Italian accents of Nos. 3, 4 and 5 may be especially useful for Tennessee Williams' characters, or for Tony in Sidney Howard's *They Knew What They Wanted*. No. 1 will serve as a model for any modern Italian woman character, educated, sensitive, vividly Italian, speaking English with only the slightest accent. In preparing a role in this accent, make it light or heavy according to the literacy or illiteracy of the character you will portray.

Vowel Changes

STANDARD	ITALIAN ACCENT	
talk	talk-a	*Uh*, respelled *a*, is added as an unstressed light syllable to words ending in plosives, in sibilants *sh*, *s* and *z*, and in the glide *l*. Use it only once or twice in a sentence, or it may sound artificial.
big	beeg	As with French and Spanish, short *i* becomes *ee*.
dummies	dommies	A short *u* may be rounded into an *aw* or a short *o* sound.

Consonant Changes

STANDARD	ITALIAN ACCENT	
the	zee	In a heavy accent, *th* voiced becomes *z*; in a light accent, it becomes *d*, or does not change at all.
they	dey	
Moscardina	Moscarrdina	*R* may be slightly trilled, as in No. 4.

Plays

Golden Boy	Clifford Odets	Joe, Bonaparte, others
The Rose Tattoo	Tennessee Williams	Serafina Delle Rose, Alvaro Mangia Cavallo, Assunta, others
Street Scene	Elmer Rice	Filippo Fiorentino
They Knew What They Wanted	Sidney Howard	Tony
A View from the Bridge	Arthur Miller	Rudolpho, Marco

Musical

The Most Happy Fella	Frank Loesser	Tony, Rosabella

GERMAN

GERMAN ACCENT NO. 1

Bruno Walter Makes His First Recording
(Speaker: Bruno Walter)

A very vivid REE-COLL-ECT-ION. We sat, like in animal cages./

round *I was very highly posted, and the orchestra HRROUND me.//*

Far below me, the tuba and the brass, and on my side the strings./

And there was no double bass allowed to play//

WITH-OUT being SUPP-ORT-ED by the bass tuba;/

otherwise the lower tone, Vienna accent, could not be RECK-ORDED!//

And the outcome was not so very enjoyable./

(D'you remember the work, the specific work that you conducted at your first session?)

Oh the first sess—I think it was the entr'acte from Carmen.///

GERMAN ACCENT NO. 2

Picking Wild Berries in Germany
(Speakers: Frau Holzer, Kathy Swan)

I got nine KRANDCHILDREN; two step-KRAND-CHILDREN;/

UND seven KRANDCHILDREN. O.K.?//

I come over from CHERMANY nineteen fifty-four, on December the twennieth./

they marry I like it here. My T'REE children, ZEE MERRY now.//

My oldest SAWN—son—MERRY Minneapolis; so my younges' son./

daughter My DAH-ER, she's MERRY in Fairbourne, Minnesota.//

My oldes' son got T'REE CHILDURN; my younges' son got two./

UND my DAH-ER got four.//

(You know, I have those rose-hip cubes, and you said you used to go out when you were a child, and pick those. D'you remember—those red berries?)

Oh YAH! when we were CHILDURN, we have to PEEK up, peek all time BLUEBEHRRIES;/ *pick*

UND I hate the CHOB; I really hate it, you know;//

they're low, those pieces;[a] 'cos you got all—VEEN you got WUUN pound, ZEY pay you ten cents; ZAT'S all that they paying!/

UND you HAF to work the WHO-OOL day long; // *whole*

UND you be TYE-HRRD; but I really hate, I hate this *tired* tough a CHOB./

I so KLAD I HAF to not do it one hour.//

Everything easier, all in THEES country./

(Ten cents!) Yeah, we HAF to work-HRRR!-haf to work.//

(Did you ever take them home and eat them?)

Yeah, VOT VE want, you know; VE pick maybe a day, 'bout HUNNER' pounds! you know, you HAF to work!/

(That many?) Dat many! You know, you HAF to work like-HRRRR!—for it; a really hard CHOB.//

I really hated it and it was hot out in the woods, you know, the sunburn; oo, everything was STICKEE! you know?/

I really CHUST hated it; but I'm working! Keep working! Need the money!///

GERMAN ACCENT NO. 3

After World War II (Speaker: Herr Epstein)

ZE mission referred to in ZE document was, of course,/

Ze first repatriation of millions of anti-Communists to Stalin's executioners and slave labor camps.//

Now, ZIS request, for more Russian interpreters, was for twenty-one years CONZIDERED ZO sensitive/

ZAT it could not be de-classified,//

in the interests of foreign policy and national defense./

ZAT means ZAT ZE PENT-A-GON was for twenty-one years of ZE opinion//

ZAT release of ZIS AGFA memorandum could result in ZE immediate outbreak of VORR,/

und breaking off of DEEPLOMATIC relations;//

or in the compromise of intelligence tha—for American *that* technology.///

GERMAN ACCENT NO. 4

From Heidelberg to New York (Speaker: Angelika Volkhardt)

I'm living in Heidelberg, in Germany, and I'm twenty-three years old./

I have a sister and a PROTHER. My sister is studying French in Munich, and my PROTHER is still at school.//

This summer I had the opportunity to come over to the U.S./

June

So I left Luxembourg in the middle of CHOON, and had a FLIIGHT over to N'York City.//

A fu' (week?) we spent in N'York City, and had time to look around;/

to WISIT the buildings, the Central Parks, and the MUSSEUMS.///

And it was so, so much to do and to see over THEAH./

But after this WEEEK, I left N'York City, and drove to a private camp;//

and this private camp was situated in the NORTH-ERN part of N'York State./

After two months, I left camp, and I drove to Boston to two families I was INWITED in.//

And it was really so much fun to be with this family, to discuss, and—to live again.///

Pronunciation and Character Notes

In assuming a German accent, concentrate chiefly on the consonant changes. You must unvoice your voiced consonants, saying *prother* for "brother," *chust* for "just," *klad* for "glad," *haf* for "have," *musseums* for "museums"—making these changes consistently. Listen to them all on the CD, so that you will get the right degree of voicelessness for each sound. You may also say *bank* for "bang," another common change.

The *th* sound, not heard in German, changes, as in French and Italian, to *d* or *z*, as the accent is lighter or heavier. When *th* is combined with *r*, as in "three," it becomes *t'ree*, as in No. 2.

W and *v* are confusing, because each may be substituted for the other. In No. 2, you hear *Vot ve*; in No. 4, you hear about being *inwited* for a *wisit*. Use either or both of these.

The German guttural *r*, much throatier than the French uvular *r*, may replace *r* in the middle of a word, at the beginning, or before a consonant, or it may be used as an expletive. You hear a fine example of this in No. 2, in Frau Holzer's indignant *HRRRR!* It is respelled *hrr*

in other instances; the two *r*'s being used to distinguished this sound from the uvular *r* of French, respelled *hr*. You can use *hrr* as Bruno Walter does in *hrround*, where it is strong and clear; or give the *r* a guttural touch only, as in *bluebehrries*, No. 2.

The inflections are more a matter of stresses than pitch changes. The general pitch level is low, in contrast with that of Italian. The pattern is one of stresses divided between syllables, as is the case with the definite syllable separation of German itself. Bruno Walter's residual German accent is a clear example of how the stress pattern clings, even when nearly all sound changes have been eliminated. You hear the divided syllables in *ree-coll-ect-ion*, *with-out*, *supp-ort-ed*. Instead of the pitch rising or falling very much, you hear a beating pattern. Compare "the outcome was not so very enjoyable"; "I so klad I haf to not do it one hour!"; "to be with this family, to discuss, and to live again."

The accent of No. 3 is an example of a mixed German-Russian quality; however, the character himself seems German.

In working on these examples, introduce the changes listed below somewhat more than in Nos. 1 and 4. Study your proposed German-accent role in relation to the types apparent on the CD. No. 4 suggests a sensitive, restrained, docile nature; No. 1 is plainly a type of genius, intellectual, temperamental, but genial; No. 3 is stubborn, dogmatic, authoritarian; No. 2 is the typical hausfrau, energetic, practical, emphatic—*HRRRR!*

Vowel Changes (Not All Those Heard on the CD are Included)

STANDARD	GERMAN ACCENT	
pick	peek	Short *i* becomes *ee* sometimes.
son	sawn	Short *u* becomes the short *o* of British English, respelled here *aw*.
brass	brahss	The broad *a* is usually heard in a cultivated German accent where it would be used in standard British English.
and	und	*Und*, German for "and."

Consonant Changes

STANDARD	GERMAN ACCENT
brother	prother
June	Choon
grandchildren	krandchildren

STANDARD	GERMAN ACCENT	
have	haf	
museums	musseums	The voiced consonants are unvoiced. See note above.
they	zey, dey	See note above for *th* substitutions.
what	vot	The *w-v v-w* are both interchanged.
visit	wisit	The guttural German *r* may remain as part of a German accent, initially or in the middle of a word, or before a consonant.
round	hrround	

Plays

After the Fall	Arthur Miller	Helga
Five Finger Exercise	Peter Shaffer	Walter Langer
I Am a Camera	John Van Druten	Fraulein Schneider, Fritz Wendel, Natalia Laudavrier
The Little Man	John Galsworthy	The German passenger, the German official, the mother
The Night of the Iguana	Tennessee Williams	Herr and Frau Fahrenkopf, Wolfgang
Watch on the Rhine	Lillian Hellman	Kurt Muller, others

Musical

Cabaret	Fred Ebb, John Kander, Joe Masteroff	Emcee, Ernst Ludwig, Fraulein Schneider, Herr Schultz, others

RUSSIAN

RUSSIAN ACCENT NO. 1

A Russian Taxi Driver on Long Life and Hard Work
by Peter Ustinov (Speaker: Robert Reznikoff)

PART I: LONG LIFE
(This section of No. 1 is spaced.)

You may have NAW:TICED THAT I am driving SLAW:LY./
DIS is because I am now//
eighty-one YEAR-RS AW:LD;/
and because I have just VEESITED DE DAW:CKTER.//
And *DE DAW:CKTER has TAW:LD me/*
that my OR-RGANS, all taken separately,//
could SUR-RVIVE ANOTHER-R HUNDR-RED YEAR-
RS *by THEMSELFS./*
They are in VAIR-Y good condition.//
But unfortunately they are all LEENKED to each AW:
THER./
And therefore if WON of them SODDENLY CAW:
LLAPSES//
well, the AW:THERS VILL join them./
And I will be, uh, dead.//
So he tell me I have much BETTER-R chance/
if I take it easy.//
So I am taking it easy./
You have PER-RHAPS NAW:TICED that I am
R-RAHSSIAN?///

Russian

PART II: HARD WORK

You can always tell R-RAHSSIAN taxi drivers/
because they got DIR-RTY taxis.//
They are all lazy people; they are always in the same café./
I can show you the café because there is a R-ROW of
DIR-RTY taxis outside.//
There they sitting, DR-RINKING coffee!/
Instead they should VWOR-RK.//
They DR-RINK coffee, discuss how they go R-RETUR-RN
to R-RAHSSIA,/

work

conquer the Soviet AR-RMY—oh!—in taxis.//
Vell then! And I go in there. I go in THER-RE, sometimes
I say,/
"You are stupid lazy people!"//
(Then we arrived at our destination and as I got out I said
to him, "You know, I'm Russian too.")
NNAW:!/
(I said, "Yes!")
AW:! Then I APAW:LOGIZE.//
(I said, "Why?")
AW:, because I know R-RAHSSIAN people. They like to
TAW:K, and I have been TAW:KING all the time. You would
PER-RHAPS have enjoyed to TAW:K!////

RUSSIAN ACCENT NO. 2

From Pasternak's *Doctor Zhivago*
(Speakers: Nicholas Levitin, Sr., and Nicholas Levitin, Jr.)

One VEENTER Alexand' ALEXANTCH [Alexandovich]
wardrobe *gave An' AYVAH-NUVNAK [Anna Ivanovna] an antique
WAR-RDROBB/*
which he had PEEKED up SOMEVER-R or other.//
ebony *It was MAY-EED of EBBOHNEE, and was so EENOR-
RMOUS/*
that it would not GAW: through any door in one piece.//
It was taken into the house in SEE-EK-TIONS./
The PR-ROBLEM then was WHER-RE to POOT it.//
*It would not do for the REE-SEPTION rooms because
of its function;/*
NOR-R for the BAYDROOMS because of its size.///

RUSSIAN ACCENT NO. 3

About Dostoyevsky's *Crime and Punishment*
(Speaker: Robert Reznikoff)

My name is Rodion Romanovna Raskolnikov;/
*and you may KNAW: me from novel by Dostoyevsky: Crime
and Punishment.//*
I VOS KNAW:N for killing old lady with axe;/
*also killing DAUGHTER-R who came into room carrying
bundles from MAR-RKET.//*

I VOS TOR-RTURED in my mind about killing these people./

It VUR-RIED me very much until finally I had to go to SUPER-RVISOR-R at police station,//

and confess that I am a MUR-RDERER-R./

At VITCH time I VOS sent to Siberia LABOR-R CAHMP.//

I had to VUR-RK VER-RY hard; they shaved off my head;/

and I VUR-RKED in salt mines for many many YEAR-RS;//

until finally they let me GAW;/

and I MAR-RIED the VUMAN I loved and lived in St. PETERSBUR-RG FOR-R twenty YEAR-RSS,//

And now I am a happy man VITH two little GIR-RLSS,/

and I MEK this tape so you know how VE talk in SOVYET Union.//

Pronunciation and Character Notes

The Russian accent in these examples includes No. 1, a lighter but genuine accent, with typical inflections, based on Peter Ustinov's stories and his manner of telling them. Robert Reznikoff, who narrates both these and No. 3, uses in the latter the same changes, but with less varied inflections. No. 2 is unusual, because in the first half you hear Nicholas Levitin, Jr., imitating his father's native accent; then you hear Nicholas Sr.'s own voice, thick with genuine Russian vowels and consonants. Both father and son use the same extremely vivid inflection patterns. For this reason the whole of No. 2 is italicized.

The chief consonant change is the heavy Russian *r*; it differs from the guttural German *r*, and so is respelled *r-r*, instead of *hrr*. It is heard most clearly and accurately in No. 2, "The pr-roblem then was wher-re to poot it." Listen to these particular *r*'s and come as close to them as you can. Throughout the examples, by no means every *r* is rolled like this, and yet, in all three, the Russian accent is effective. Use it yourself in middle positions especially, as in *hundr-red, dir-rty, mar-rket*.

The change of *w* to *v* is also irregular. It has not occurred in the *wher-re* of No. 2. It is common in *vos, vill* and *ve*, however.

The vowel change for the sound to which *oh* changes respelled *aw:*. The colon draws your attention to the fact that the *aw* is sustained a little. Since the *aw* in "paw" or "bawl" is pronounced differently in different regions of North America, make sure to learn this sound from the CD rather than from the respelling.

The vowel change from short *i* to *ee* is only heard occasionally, usually in the emphatic verb: *leenked* for "linked," *peeked*, "picked."

Short *e* in "sections" No. 2, changes to *see-ek-tions* (nearly to *see-ayctions*). But in "bedroom," the short *e* changes to *ay: baydroom*. Confirm this as you listen. Use only one of these two changes yourself. The long *a* of "made" is *may-eed* in No. 2. This is also an extreme and a difficult change. If you use it, simply lengthen the second half of the diphthong *ay*, which phonetically is *eh-ee*. This change is not needed except for a very heavy Russian accent.

As to characterizations, the Russian taxi driver's stories are good to play and say, both for learning the fundamental accent and for the portrayal of an elderly character. The slow speed, the heightening of the pitch changes for comic effect, the short sentences and the uncomplicated sound changes make it easy to follow. No. 3 with its longer sentences and less exaggerated inflections will serve for straight Russian roles. But for a part requiring a really marked Russian accent, simply memorize the whole of No. 2. Learn the difficult Russian names and all. Follow the sharp change in pitch within words and phrases: "so ee-NOR-rmous!"; "in see-EK-tions!"; "where to POOT it?" Keep your articulation clear, transfer these qualities to the lines of your role, and you will be understood even with as strong an accent as this.

Vowel Changes

STANDARD	RUSSIAN ACCENT	
linked	leenked	Short *i* to *ee* sometimes.
sections	see-ek-tions	Short *e* changes variously.
bedroom	baydroom	See note above.
made	may-eed	See note above.
go	gaw	Unround the normal *oh* to the *oh* heard in this word on the CD. It is close to *aw*.

Consonant Changes

STANDARD	RUSSIAN ACCENT	
organs	or-rgans	*R*, especially a middle *r*, is a thick sound between a guttural and a trilled *r*.
will	vill	*W* becomes *v* irregularly.
years	yearss	Final *s* may be lengthened and unvoiced after a consonant.

Recording
Fiddler on the Roof, Capitol

Plays

Anastasia	Guy Bolton	Dowager Empress, Chernov, Vanya, Sergi, others
Anna K.	Eugenie Leontovich	Anna, other Russians
The Love of Four Colonels	Peter Ustinov	Colonel Alexander Ikonenko
Fiddler on the Roof	Joseph Stein	Constable
Ninotchka	Melchior Lengyel	Ninotchka, Ivanov, Braakov, others
You Can't Take it With You	George Kaufman and Moss Hart	Grand Duchess Olga, Boris Kolenkhov
The Doukhobors	Paul Thompson	All Russian characters

SPANISH

SPANISH ACCENT NO. 1

Epiphany in Puerto Rico (Speaker: María Rolán)

This is a very special day for the KEEDS./
The day before EPEEPHANY, they go OUT-SIDE,//
and they PEECK some grass in LIDDLE boxes,/
BECOSS they believe the camels are CAWMING hungry// coming
for such a long TREEP./
And so they have to put them something to eat and
DREENK.//
And they gather this boxes of grass, and put some LID-DLE
WAWDER under their beds,/
And in DE morning DEY receive DER PRESSENTS,//
USHALLY AWNDER the beds,/
or very near a NATEEVITY scene//
that the PAHRNTS set in the LEEVING ROOM./// parents

SPANISH ACCENT NO. 2

One Production of Garcia Lorca's *The House of Bernardo Alba*
(Speaker: Alberto Castilla)

Saragossa	I'm Alberto CASTILLYA, and I came from Spain, from STHARGOSTHA,/
	which is a ciddy AHP in DE north a' Spain,//
Pyrenees	near DEE PIRNEE mountains, VER' CLAWS to France./
	And I studied at the University of STHARGOSTHA;//
	HUMAHNITIES and THEADER; we used to play some SPAHNISH plays in Spain;/
	'bout FO-FI years ago we played some SPAHNISH
Garcia Lorca,	playwrighters like GARTHIA LOR-RCA and MODTHERN
modern	field;//
Cervantes,	and also played some classical playwrights like SAIRR-
Lope de Vega	VAN-TAYZ and LOPAYTHAVAYGAH./
	We went to Colombia, in South America;//
	And the we WORRKED at DEE University Nationale of Colombia.///
	(Have you seen any Lorca done here?)
	I saw LOR-RCAS in some other country;/
	I saw La Casa de Bernarda Alba in Madrid;//
	and I saw DEES play also in Mexico./
Prague	and finally a group from PRAGA, from Czecho-slovakia;//
roles	It was very interesting because the RAWLLS of the women were played by men—all!/
	All men; it was very very strong performance and very unusual.//
	And I think was very good./
	La Casa de Bernarda Alba is a play only for women.//
	(Oh yes, I—)
	There are about fifteen CHAHRCTER; all women./
	(The House of Bernarda Alba!)
	DAT'S right; no men.//
performed	*And DEES performance in Czechoslovakia was P'FOMM'*
only	*AWNLY by all men;/*
	and it was great; because you know, the CHAHRCTERS in DEES play,//
	DEES women are ver' very hard women; s'posed to be very hard and strict women./
	And so for, I would say for a number of women, quite DEEFFICULT to create DE CHARACTER.//

AHZ for AY man, it's quite easy to create!/ *as*
I mean, DE result was fascinating./
I enjoy very much.///

SPANISH ACCENT NO. 3

Theatre in the Philippines (Speaker: Andre Balthazar)

I was born i' the Philippines./

I'm going to talk about theatre in the Philippines.//

By theatre, I mean the legitimate stage./

Actually there are four major dramatic guilds in the Philippines.//

That is, of course, ESSCLUDING de M-T-G, which is ex- *excluding*
clusively American PERSONNAHL./

I would like to enumerate it, if you want to; DEY are DE following:///

Barangay Theatre Guild; th'AHQUINUS Dramatic Guild;/ *Aquinas*
DE Tambuda Playhouse; and, finally, DEE Arena Theatre.//

The Barangay Theatre Guild is headed by MEESTER and MEESEZ Umberto AVALLYANA./

I would consider Berto AVALLYANA as THEE d'rector *Avallano*
of the Philippines.//

Then the Aquinas Dramatic Guild is headed by Father Antonio Piñon./

He's a Dominican priest; versatile director at that; I enjoy working with him.//

Then as for DE Tambuda Playhouse, this is headed by Antonio Carion./

And finally DOCK-TER Severino Montano, who has DEE Manila Arena Theatre.///

Pronunciation and Character Notes

The three examples loosely grouped on this CD as Spanish accent are very different from each other. No. 1, a Puerto Rican Spanish, contrasts with No. 2, which is based on classic Spanish, a full, rich, authentic accent. It in turn contrasts with No. 3. No. 3, an example of Philippines English, is related to the native Tagalog as well as to Spanish. Spanish in the Philippines is now merely learned in the universities as an acquired language. It is spoken there only by a small

group considering themselves the elite. The English of No. 3 is that of the Manila radio and the TV announcers who pattern their English on North American English. That is also the case with No. 1, in which you hear *liddle wawder* for "little water," and No. 2, *ciddy* for "city" and *theader* for "theatre."

Spanish influence is heard in the double *l* of the proper names "Castilla" in No. 2 and "Avallano" in No. 3. This is represented in the respellings *Avallyano* and *Castillya*. A trilled *r* is heard in *Lor-rca*, and very slightly in *wor-rked*. The *d* of *modthern*, as in Mexican, is dentalized, and slips toward a voiced *th*. The respelling is approximate. (See the notes on Southwestern 4, 5 and 6.) The same variant is heard in Lope *dtha* Vega. Initial *th*, however, is often *d*; "the," "they," "that" are near *de, dey, dat*.

The *th* sound in pure Castilian Spanish is substituted for all the sibilants, *s, z, sh* and voiced *sh*. Listen carefully to No. 2, and you will hear it in *Garthia* for "Garcia." Likewise in No. 2 in the first sentence there is a suggestion of it in the place name Saragossa. The speaker, a Northern Spaniard, pronounces it *Sthargostha*. For a Madrileño, as you will find on recordings, the substitution of *th* for a sibilant is so common that the speaker may sound as if he has a pronounced lisp. This is the case in Spanish, and the same substitution is often heard in Spanish-accented English.

The substitution of *ee* for short *i* is constant in the Puerto Rican example. (Again, compare Mexican.) It is frequent in No. 2, but in No. 3 is heard only once—*Meester* and *Meesez*.

As to characters in plays, for a Puerto Rican role, use No. 1, but recognize that this is an educated accent. Adapt it for other types of Puerto Rican roles. For a European Spanish accent, use No. 2. It has characteristic bursts of speed in English as well as in Spanish. Try especially to match the tempo of "I-saw-Lor-rcas-in-some-other-country"; "It-was-very-interesting-because . . ."; "Dees-performance-in-Czechoslovakia-was-p'fomm-awnly-by-all men." Along with the speed is the up-and-down pitch pattern of all Romance-language-based English. But Alberto Castilla's English is hard to follow at such times. Match his speed, his rhythm and his pitch patterns, but not his slurred consonants. Keep your articulation clear.

Andre Balthazar's English is included here because it might serve for the role of an educated English-Spanish character whose origins are in the Pacific area. Notice some native elements not heard in Nos. 1 or 2; *Dock-ter; esscluding*.

Vowel Changes

STANDARD	SPANISH ACCENT	
trip	treep	Short *i* becomes *ee*, frequently in Puerto Rican English, residually in educated Spanish.
parents	pahr'nts	Short *a* and *u* become *ah*.
Spanish	Spahnish	
up	ahp	
close	claws	*O* becomes *aw*.

Consonant Changes

STANDARD	SPANISH ACCENT	
the	de	*Th* becomes *d*, especially in *the*, *they*, *that*.
Lorca	Lor-rca	The trilled Spanish *r* is heard in proper names only.
modern	modthern	*D* is dentalized, made low on the inside of the upper teeth rather than on the gum ridge just above. Listen to this also in the General European example following on the CD: *dthake*, "take"; *dthidn't*, "didn't"; *retthained*, "retained."
Castilla	Castillyah	See above.
Garcia	Garthia	*Th* voiced is substituted for *s*, also for *z*, *sh* and voiced *sh* in Castilian Spanish accent.

Plays

Man and Superman	George Bernard Shaw	Mendoza
Steambath	Bruce J. Friedman	Locker Room Attendant (a Puerto Rican)
A Sunny Morning	Serafin and Joaquin Alvarez Quintero	All characters

GENERAL EUROPEAN

The Best English Is Spoken on the Atlantic Ocean
(Speaker: Maria Clodés)

(What was your native tongue? Was it French or Spanish?)
AHCTUALLY I VOS BAZICALLY bilingual, French and Portuguese./
(French and Portuguese?) Yes. (I see, I see.)
Because I VOS born in France, and so I got French from my nurse and the surroundings, and,//
And my family was also speaking French WIZ me at de TTHIME./
And then when we went to Brazil before the war, I was very young actually, three, four,//
And I realized the children did not speak French./

take My, that was a BEEG crash on me! I couldn't DTHAKE it take easily, you know.//
And DE moment I could speak Portuguese, I for- (got?) I DTHIDN'T dare to say a WAWRD in French./
And I do speak many languages.///
So I really don't know which kind of accent you are going to convey through my speech, because,/
Yes, it's very MEEXED; there's nothing pure about my speech, because,//
In Europe I lived in CHERMANY for quite a long time, and,/
I LEEVED in EETALY for quite a long time,//
So I have EETALIAN and German just as well./
My father used to say that—very wisely—the best language is spoken on the Atlantic Ocean;//

retained *because, you see, we RETTHAINED a lot of seventeenth-century mannerisms and way of speaking that they left behind./*
And so in many ways, we are very CLOHZ WIZ classical language;//
less, in many ways, th' European countries; they got much more contact with the other countries; and they tends to change much more than we DEED./
Now in Brazil and in South American we of course had an enormous influence of the Negro; and that changed our language very much.///

Pronunciation Note

There is a blend here of vowel and consonant changes heard in various European countries. Use this accent to portray a cosmopolitan character. Although not mentioned on the CD, Roumanian is another language in which the speaker is fluent.

Plays

My Fair Lady	Alan Jay Lerner and Frederick Loewe	Zoltan Korpathy
The Great White Hope	Howard Sackler	Ragosy

END NOTES

[a] Pieces, probably *Stücke*; sticks, pieces, branches.

8
SYMBOLS AND SOUNDS OF THE INTERNATIONAL PHONETIC ALPHABET

Listen to the introduction on CD Three. The symbols or letters of the International Phonetic Alphabet are listed in the order in which you hear their sounds on the CD.

CONSONANTS

The Plosives

SOUND			PHONETIC
t	as in	*t*oe	t
d	as in	*d*oe	d
p	as in	*p*at	p
b	as in	*b*at	b
k	as in	*k*ey	k
g	as in	*g*ay	g

The Fricatives

f	as in	*f*at	f
v	as in	*v*at	v
th	as in	*th*atch	θ
th	as in	*th*at	ð
s	as in	*s*eal	s

z	as in	*z*eal	z
sh	as in	a*sh*	ʃ
z	as in	a*z*ure	3
h	as in	*h*ot	h

The Blends

ch	as in	*ch*ip, t plus *sh*	ʦ
g	as in	*g*yp, d plus z (the *z* in azure)	ʤ

The Nasals

m	as in	ra*m*	m
n	as in	ra*n*	n
ng	as in	ra*ng*	

The Glides

l	as in	*l*est	l
r	as in	*r*est	r
y	as in	*y*es (*j* is not the sound in *jay*, but in *ja*)	j
w	as in	*w*est	w
hw	as in	*wh*ew!	ʍ

THE VOWELS

The Front Vowels
as in W*e* will t*a*ke *a*ny bl*a*ck c*aa*s (New England dialect for c*a*rs).

ee	as in	w*e*	i
i	as in	w*i*ll	ɪ
a	as in	t*a*ke	e
eh	as in	*a*ny	ɛ
a	as in	bl*a*ck	æ
a	as in	c*aa*s (New England dialect, cars)	a

The Back Vowels
as in Ch*a*rles w*a*nts *a*ll *o*ld b*oo*ks t*oo*.

| a | as in | Ch*a*rles | ɑ |

a	as in	w*a*nts		ɒ
a	as in	*a*ll		ɔ
o	as in	*o*ld		o
oo	as in	b*oo*ks		ʊ
oo	as in	t*oo*		u

The Mid Vowels
as in (American standard) m*o*th*e*r b*ir*d

u	as in	m*o*ther	ʌ
er	as in	moth*er*	ɤ
ir	as in	b*ir*d	ɝ

as in (British standard) mothe(r) bi(r)d, *r*'s silent

u	as in	m*o*the(r)	ʌ
er	as in	moth*e*(r)	ə
ir	as in	b*i*(r)d	ɞ

The Diphthongs
as in M*ay* *I* j*oi*n y*ou* n*ow*, J*oe*?

ay	as in	m*ay*	eɪ
ie	as in	*I*	aɪ
oy	as in	j*oi*n	ɔɪ
ew	as in	y*ou*	ju
ow	as in	n*ow*	aʊ
oh	as in	J*oe*	oʊ

SPEAKERS FOR EACH DIALECT
MIDWESTERN

1. Leo B. Marsh
2. Mrs. Leo B. Marsh
3. Gary Bass

SOUTHWESTERN

1. Maureen McIntyre
2. Larry Evans

3. Brenda Keith
4. Raul Huerta
5. John Peters
6. Jacqueline Margolis

SPANISH WORDS: Judith Sanchez

SOUTHERN

1. Florence Trawick
2. Philip Howerton
3. Kathy Swan
4. Shelia Russell

NEW YORK-BROOKLYNESE

1. Frank Cass, Frank Zito
2. Myra Zito
3. Dorothy Meyer, Robin Brecker

BLACK AMERICAN

1. Larry Roland
2. Sairy Guinier
3. Brenda Davis, Alfré Woodard and Janet Wardham
4. Ellis Williams

BLACK AFRICAN

1. Ola Rotimi
2. Aaron Hodza (Shona)
3. George Kahari (English)

YIDDISH

1. Alene Weissman
2. Louis Bloomberg
3. Linda Cohn, Sue Weintraub

YANKEE

1. Robert Bryan
2. Margo Skinner
3. Captain Nickerson
4. William Lyman, Stephen Klein

FRENCH CANADIAN

1. Joan Stuart, Peter Cullen
2. Bruce Gordon
3. Laurier LaPierre

STANDARD NORTH AMERICAN

1. Marian Seldes
2. Howard K. Smith
3. Muriel Dolan
4. Mavor Moore

PAIRED SENTENCES,
STANDARD NORTH AMERICAN and BRITISH

Group 1, Bob Osolinski, Rowena Stamp
Group 2, David Alkire, Evangeline Machlin

STANDARD BRITISH

1. Margaret Webster
2. Patrick Tucker
3. Rowena Stamp
4. Jeremy Dix-Hart, Robert Reznikoff

COCKNEY

1. Actors playing Rummy and Snobby
2. Robin Bartlett, Judith Robinson
3. Robin Bartlett, Judith Robinson

WELSH

1. Patrick Tucker
2. An unidentified Welsh farmer
3. George Imrie

NORTH BRITISH

1. Stephen Nuthall
2. Stephen Nuthall
3. Schoolchildren of Wakefield, Yorkshire, with Sally Nuthall
4. George Imrie

SCOTTISH

1. Brian McKay
2. Barbara Karp
3. Jamie Copley
4. George Emmerson

IRISH

1. Radio Eireann actors
2. Christopher Johnson
3. Martin Anderson, Judith Doble
4. Allan J. Gruet
5. Peter Gibson

FRENCH

1. A French woman from the French Consulate in Boston
2. Alain Habert
3. Jeanne Colony
4. James Sherwood

ITALIAN

1. Anita Sangiolo
2. John Peters
3. Diane Grudko
4. John Peters
5. Karen MacDonald

GERMAN

1. Bruno Walter
2. Frau Holzer, Kathy Swan
3. Herr Epstein
4. Angelika Volkhardt

RUSSIAN

1. Robert Reznikoff
2. Nicholas Levitin, Sr., and Nicholas Levitin, Jr.
3. Robert Reznikoff

SPANISH

1 María Rolán
2. Alberto Castilla
3. Andre Balthazar

GENERAL EUROPEAN

1. Maria Clodés

The author and publisher are grateful to the following for permission to reprint and record as indicated:

for the selection from *American Speaking* by Raven I. McDavid, Jr., published in Champaign, Illinois. Copyright © 1967 by the National Council of Teachers of English. Used by permission of the Publisher and Raven I. McDavid, Jr.

for the excerpt from "L'Anglaise" by Arthur S. Samuels, spoken by Joan Stuart from *Funny You Should Say That* (RCA Victor Record LSP 4352, CBCLM 72). Used by permission of Arthur S. Samuels and Joan Stuart.

for the selection from *The Art of Ruth Draper*, edited by Morton D. Zabel. Copyright © 1960 by Doubleday and Company, Inc. Use by permission of the Publisher.

for "Black Woman" from *Don't Cry, Scream* by Don L. Lee. Published by Broadside Press, Detroit Michigan, and used with the permission of the Publisher.